GREEK AND ROMAN ART

The Fitzwilliam Museum has arguably one of
the finest collections of antiquities in the United
Kingdom. Assembled mainly through bequests
and gifts, it is a stunning exhibition of connois-
seurship. This splendidly illustrated book presents
sixty-four images of the finest examples of
Greek, Etruscan, Cypriot and Roman art dating
from the Prehistoric to the late Roman Period,
and ranging from the monumental to the decora-
tive. The concise text provides an introduction to
the art, technology and history for the layman,
as well as new insights for the expert. Many
of the objects are published here
for the first time.

GREEK AND ROMAN ART

ELENI VASSILIKA

KEEPER OF ANTIQUITIES, FITZWILLIAM MUSEUM

PHOTOGRAPHY BY ANDREW MORRIS

AND ANDREW NORMAN

CAMBRIDGE
UNIVERSITY PRESS

PUBLISHED BY THE PRESS SYNDICATE OF THE UNIVERSITY OF CAMBRIDGE

The Pitt Building, Trumpington Street, Cambridge CB2 1RP, United Kingdom

CAMBRIDGE UNIVERSITY PRESS

The Edinburgh Building, Cambridge CB2 2RU, United Kingdom http://www.cup.cam.ac.uk

40 West 20th Street, New York, NY 10011–4211, USA http://www.cup.org

10 Stamford Road, Oakleigh, Melbourne 3166, Australia

First published 1998

Printed in the United Kingdom at the University Press, Cambridge

Typeset in Quadraat 9.5/13.75 pt, in QuarkXPress™ [SE]

A catalogue record for this book is available from the British Library

ISBN 0 521 62378 2 hardback
ISBN 0 521 62557 2 paperback

This book is dedicated to the memory of
C. S. RICKETTS (AD 1866–1931)
and
C. H. SHANNON (AD 1863–1937)

CONTENTS

Introduction 1

INTRODUCTION

The intention of this book is to present a treatment of Greek, Etruscan, Cypriot and Roman art from the rich collections of the Fitzwilliam Museum. It was indeed difficult whittling down the list of highlights to the Handbook format of sixty-four images, and that is one reason why so many group photographs were included. Whereas most studies of classical art are approached through the decorated vases or sculptures, an effort has been made to include a broad range of monumental, decorative, glyptic, and even everyday, beautiful objects. In any case, the Greek vases in the Museum have already been published in two volumes; likewise the marble sculpture. To some extent the choice of objects reflects the strengths of our collections, and thus there will be lacunae in the coverage of the arts (e.g. mural painting). However, much of the collection is unpublished, and a special attempt was made to include the lesser-known material. Jewellery is also not included because this class of material will be handled separately within the series. The objects are presented chronologically, and region by region, using the finest examples within the collections. Scholars in the various sub-disciplines may take exception to the choices, but this book is intended for the general reader. Thus, care was also taken to include as many examples as possible of the pantheon, and some of the exploits of heroes, as a kind of introduction to the subject. The text also attempts to furnish information about the developing technologies trade, and also some historical events.

The collections of the Fitzwilliam Museum at the University of Cambridge were derived from bequests, gifts, modest purchases, and from divisions of antiquities from excavations in Greece and Cyprus, subscribed to by the Museum. Apart from this last category, the bulk of the material was acquired for its aesthetic and art historical merit in a fine art context, rather than as a type series in an archaeological institution. Indeed, there is a school of thought that objects of antiquity lacking an archaeological provenance have no information to offer, having lost their context. However, time and again we see that the objects furnish information about available materials, trade, tools, methods of manufacture and assembly, as well as providing pleasure. With the rise of theoretical archaeology, there has been a lessening of interest in 'material culture', which has helped to engender some antipathy towards the art historical study of objects. Some archaeologists have gone a step further in

discouraging the publication of unprovenanced objects which they feel otherwise inflates values and encourages the looting of ancient sites. I feel that price inflation of antiquities has more to do with aesthetics, material, quality and rarity, and less to do with publication. Indeed on that basis we should not study and publish Georgian silver or Chippendale furniture, fearing we would thereby inflate their values and encourage thieves. Conservators have also been urged not to conserve material which is on the art market. Here I think we show our extreme cynicism for works of art. As soon as an object is removed from the soil, it begins to atrophy and so the object starts to self-destruct. I feel strongly that everything should be studied, and all possible information extracted from an individual object which obviously will not go back into the ground or to its original context. Only a small percentage of the collections in the Fitzwilliam Museum has an archaeological provenance, but it would be wrong not to study the material and make it publicly accessible. We can date Attic Greek vases and marble sculpture stylistically to within twenty-five years of production, and thus archaeologists would do well to learn the methods of art history, and art historians should not ignore archaeological contexts. The two disciplines should not be mutually exclusive.

Skipping through time, the sculptures presented here reveal the steady development in approach to the human form from the volumetric (no. 1) to the abstract (no. 2), and to the salient gesture (no. 4). Suddenly, with the increase in contacts with and borrowings from the east in the seventh century BC (no. 6), the development of the human figure accelerates (no. 8). A few exceptions of seeming provincialism (nos. 9, 10) seem to represent a kind of short-hand stylisation in a religious context. The development of the figure continues in the sixth century BC and is aided by the experiments in bronze casting (no. 12), which allow gesture and movement in space uninhibited by the negative space-fillers necessary in other materials, where breakage of projecting limbs was a real possibility. The definition of the two-dimensional figure becomes highly detailed on pottery, where there is a rotation of the planes of the body in order to accommodate the most striking elements in a single viewpoint (no. 13); this kind of approach is addressed in the following fifth century (no. 26). Meanwhile, in Etruria and Cyprus there were specialised industries in metal-work (no. 17) and terracotta (no. 22) production. The native graphic traditions (no. 16) were followed by imitations of Greek wares (no. 18). In Cyprus the artisans received inspiration from the east in the seventh and sixth centuries BC (nos. 21, 22).

The fifth and fourth centuries BC witnessed further figural experimentation with canons of proportion, with rest and action (nos. 28, 29), and with the evocation of pathos (no. 31). Following the conquest of the east by Alexander the Great (no. 33), there is not only a new divinising component (nos. 33, 50) in the production of art, but also one of movement (nos. 34, 36), reflection (no. 38) and genre (no. 39). Although Italy and Cyprus followed Greek artistic inspiration from the fifth century BC, the interpretation of Greek myth (nos. 41, 42) and the practice of burial (no. 43) and temple ritual (nos. 44, 45) maintained distinctive local traditions.

The Roman Period was one of relentless production of monuments, major and minor, in imitation and interpretation of, and departure from, the Greek. New gods were assimilated from the east (nos. 50, 51), as was the idea of human deification (nos. 55, 58, 59). The introduction of such ideas required the building of monuments and the design of cult statues which were instantly recognisable. Interest in the decorative arts, such as glass production (no. 47), gem engraving (nos. 52, 58) and mosaics (no. 64) stemmed and flourished from the Hellenistic Period. Technologies were improved, so that, for example, mirrors would be more reflective and affordable (no. 42), and glass could be made in almost any shape and imitate more precious materials (no. 47). Craftsmen became adaptable (no. 52) and learned to work with silicious materials, not mastered to this extent before outside the east (nos. 53, 61). Ingenious objects for everyday use, such as the folding pen-knife, were invented (no. 62). The extent of the Roman Empire made materials such as certain gemstones and ivory (no. 57) more readily available. Despite this great new world, the Romans did imitate (nos. 46, 49, 50, 51) the innovations, styles and monuments of the Greeks. Nevertheless, certain parts of the Empire remained resolute in their pursuit of native beliefs and practices, depicting them in modes that did not conform to the Imperial ideal.

Occasionally visitors to the Museum will ask whether the works of art on view are really ancient. This uncertainty may come as a surprise to museum staff, but it does reflect our general wonder at, and incomprehension of, antiquity, and our marvel at the survival of material culture, coming as we do from a disposable one. Many visitors are incredulous at the developed ancient aesthetic, despite the often fragmentary nature of the material which survives, and the vicissitudes of time and burial which it has endured. Through exposure to ancient art, one is no longer distracted by the missing nose or limb of a sculpture, and the visitor sees the beauty within the fragment miraculously preserved.

The works of art presented on these pages are derived from temple (votive), funerary and settlement contexts, and often the exact significance of the pieces continues to elude us. The duty of the Museum is to ascertain the antiquity of an object, determine its method of manufacture, glean all possible information from it, and attempt to give an interpretation. Every addition to the corpus of antiquity can be illuminating. It is hoped that the eclecticism employed in this presentation of ancient objects from the Fitzwilliam's collections is not only representative of the course of history, the art production, and the particular strengths of the collections, but that it is pleasing and compelling. Thus it may be absorbed, partially at least, encouraging further interest in the subject.

The preparation of this book could not have been possible without the curatorial aid of Dr Penelope Wilson, the conservation expertise of Julie Dawson, and the technical assistance of Robert Bourne and Louise Jenkins who helped with the conservation, recording and mounting of the contents of this book. The superb photographs, some of which were double-exposed for the sake of more than one view and as a printing economy, were undertaken with great technical virtuosity and sympathetic eyes by Andrew Morris and Andrew Norman. The text was greatly improved by Leigh Mueller of Cambridge University Press, and through the penetrating insights and sharp eyes of Professors Martin Robertson and Geoffrey Martin. Thanks are also due to the wisdom of some of my predecessors, especially Winifred Lamb and Richard Nicholls. Finally, profoundest gratitude is due to the generous collectors who have given objects to the Department of Antiquities, noted at the top of each section, among whom C. S. Ricketts (1866–1931) and C. H. Shannon (1863–1937) deserve special recognition. It is to the memory of these two great connoisseurs and benefactors that this book is dedicated.

<div align="right">

αἰωνία ἡ μνήμη αὐτῶν

(May the memory of them be eternal.)

</div>

NEOLITHIC WOMAN

—

GR.157b.1909 *Marble. Height 11.8 cm, width 5.2 cm, depth 6.6 cm.*
Neolithic, Early (?) 6000–5200 BC. From Avaritsa (Meliteia) in Thessaly.
Given by Professor R. M. Dawkins, 1909.

In contrast with the long Paleolithic Period, the Neolithic was comparatively brief and revolutionary (6000–3200 BC). Man settled in communities, built rudimentary houses and hearths, cultivated crops, domesticated animals, and fashioned pottery and figures. A profound advance was the development of seafaring trade, which explains a frequent uniformity in the use of materials, technique and the production of objects. Although cemeteries and grave goods were a late development, figures of men, women and animals in terracotta or in marble have been found in purposeful deposits in houses and sometimes in numbers suggesting the presence of a shrine. Thus, it is thought that such figures served a ritual or magical purpose for the living, implying a belief system similar from region to region.

Pear-shaped figures of women, traditionally called steatopygous, presumably had fertility associations. Here the abstract and now headless figure is shown with arms folded across the midriff above a large, possibly ante-natal belly. The pubic triangle is emphatic. The obese thighs are creased above the knees, below which the legs are abbreviated, concentrating attention on the considerable belly. The act of birth may be inferred from the position of the arms and the pronounced crease at the knees which may suggest that the legs are flexed. The dowel hole at the top of the neck may be evidence for a separately attached head, not necessarily in the same material. Although the quality of the more numerous terracotta figurines is variable, the marble ones, which were worked with flint, tend to show competency. Both terracotta and marble versions of this type, datable to the Early Neolithic Period (6000–5200 BC) have been found in Thessaly.

Further reading Budde and Nicholls, *Catalogue,* cat. no. 1; G. A. Papathanassopoulos, *Neolithic Culture in Greece.* Athens: Museum of Cycladic Art (Athens, 1996, pp. 23ff., 49ff., cat. no. 230; A. Tsouknidas, in *La Thessalie, Quinze années de recherches archéologiques, 1975–1990. Bilans et perspectives. Actes du Colloque International, Lyon 17–22 avril 1990* (Athens, 1994), pp. 119–20, fig. 279; Dickinson, *Aegean Bronze,* pp. 32ff.

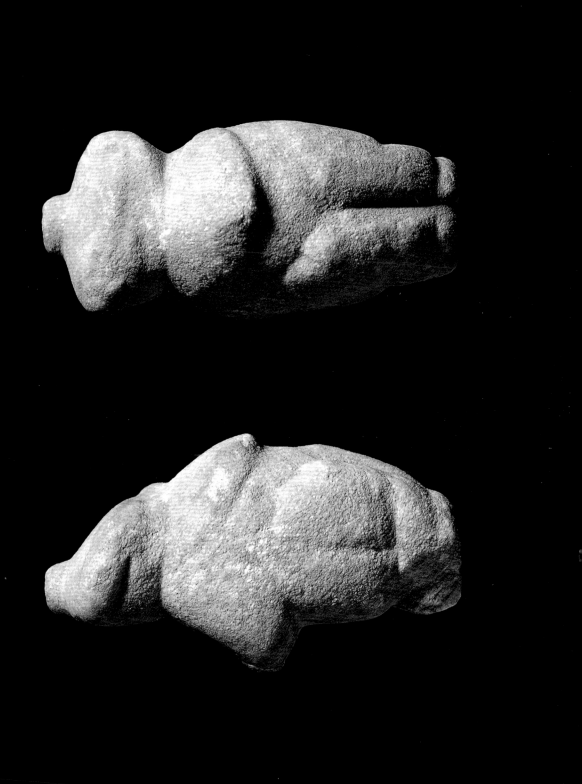

CYCLADIC

—

GR.35.1901 Marble oblong bowl. Length 23 cm. GR.51.1902 Dark burnished
collar-necked jar. Height 12.2 cm. From Pelos, Tomb 8. GR.34.1901 Green lava pyxis.
Height 6.8 cm. GR.33.1901 Marble figure. Height 25.8 cm. GR.79.1923 Pottery bowl
with leaf impression. Diameter 11.8 cm. From Chalandriani Syros. GR.7b.1923 Marble
footed bowl. Height 5.1 cm, diameter 8.5 cm. From Chalandriani (?). GR.3.1922
Double pyxis. Length 11.8 cm. GR.36.1901 Stone bowl with lug. Diameter 19.2 cm.
Early Cycladic I–III, c. 2500–2000 BC. 1901 numbers given by Professor
R. C. Bosanquet, that in 1902 by A. J. B. Wace, all others given
by the Greek Government.

It is not actually known how goods were produced in this early period in the
Cycladic islands: whether in workshops or in developed household produc-
tion; in any case there is a degree of uniformity and a movement of goods
throughout the islands, evident from the remains. The material shown here
illustrates a range of vessel shapes and materials of the third millennium BC.
The pottery, pre-dating the introduction of the potter's wheel, could be deco-
rated by burnishing the surface with a smooth stone and filling linear incision
with paste, a practice which survives much later elsewhere (no. 16). In one
example, the vessel was carefully placed on a leaf to dry for a lasting impres-
sion. The more labour-intensive stone vessels were produced generally in
shapes similar to ceramic ones, with little concern for the hardness of the
medium. Perhaps some of the stone vessels were meant for day-to-day pur-
poses not suitable for pottery, such as for use as mortars, but most were prob-
ably made for display, ritual, and, especially rich graves.

The marble human figurines with abstract features have generated much
interest. Mostly of females, with arms crossed over the waist and sometimes
overtly pregnant, it is not clear whether these are cult images or votaries. With
flexed knees and pointed feet, they were clearly not intended to stand. The folded
arms may be a gesture of respect, or suggest the final pose of the deceased.
However, they were found in both settlements and graves, and were often interred
broken or repaired, implying a life-long cult use perpetuated in the grave.

Further reading Thimme and Getz-Preziosi, *Art and Culture*, pp. 71ff., 99ff., 109ff., cat.
nos. 161, 330, 350–351, 373, 414; Dickinson, *Aegean Bronze*, pp. 169ff., 260ff.; Renfrew,
in Fitton, *Cycladica*, pp. 24ff.

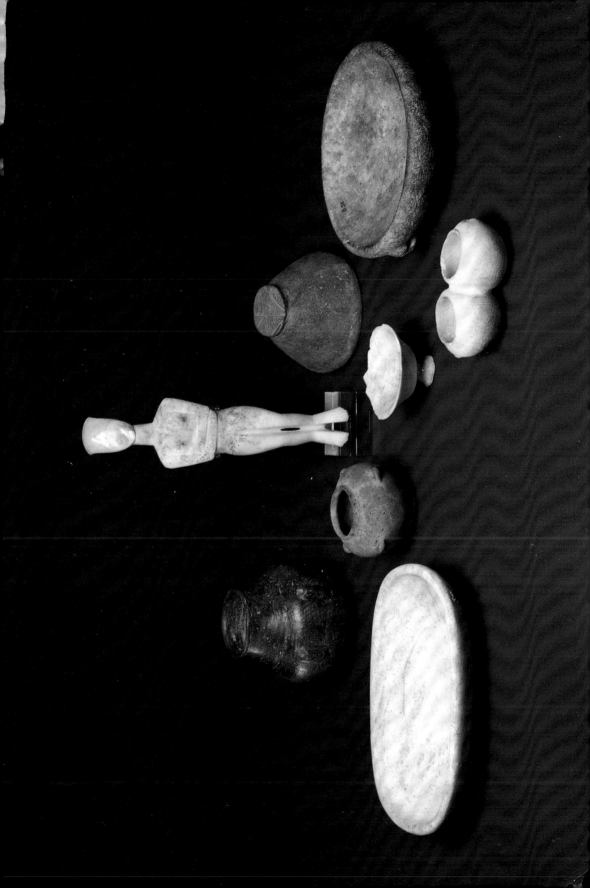

ENGRAVED MINOAN SEAL

GR.118.1937 *Sapphirine chalcedony intaglio of a feeding calf. Width 2.2 cm.*
Fourteenth century BC *(LM* III, A*), Late Minoan culture (Cretan), provenance unknown.*
Bequeathed by C. S. Ricketts and C. H. Shannon.

The Minoan culture, centred on the island of Crete but with wide contacts, influence and trade associations in the Aegean, produced some of the most exquisite art of the Bronze Age (c. 3100–1100 BC). The pottery – the standard measure of ancient aesthetics and iconography, and an excellent dating tool – was beautifully painted, often with floral or faunal subjects. Minoan architecture adapted to the natural landscape, following the contours of valley sides and rocky crags. The walls of buildings were brightly painted with murals depicting ritual, daily life and the landscape. The Minoans and their successors, the Mycenaeans, worked metal with astonishing competency, alloying both precious and base metals, patinating and inlaying complex scenes as if with a paintbrush. In addition to these major arts, they were master engravers. They engraved both on gold (ring bezels) and on stone, and always in miniature.

This fine gem dates to the Late Minoan III Period which was, to all intents and purposes, Mycenaean. It is in pale blue chalcedony, lentoid shaped and domed, and was carved using a fine bow drill. The composition of the cow and a feeding calf fills the surface area perfectly. One has to admire the respect for life and the acute observation of the details of nature, even on objects of daily use. The different modelling depths are subtly achieved, despite the convention of the knobby joints of the limbs and the over-large eyes. It is remarkable that the ancient craftsman was able to operate and control his drill on this small scale. There is no substantial evidence for the use of magnification at this period. The gem was perforated vertically through its thickness for suspension, again with the drill. To avoid fracturing the stone, the craftsman carefully drilled part of the way, stopped, turned the stone around and drilled from the other side to meet the first perforation. The engraved gem was used as a seal and was decorated with a reverse image in mind.

Further reading G. Walberg, *Tradition and Innovation. Essays in Minoan Art* (Mainz, 1986), chs. 1–2; Boardman, *Greek Gems*, pp. 46ff.

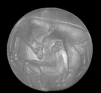

[actual size]

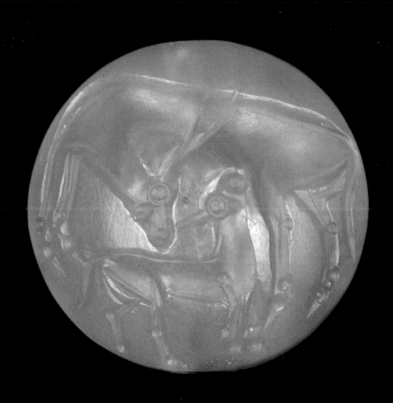

MYCENAEAN TERRACOTTA FIGURES

‒

TERRACOTTA, HAND-MADE, FIRED AND PAINTED
GR.15.1984 Phi-figure. Height 11.8 cm. GR.21.1924 Psi-figure.
Height 11.7 cm. Given by Professor A. J. B. Wace. GR.17.1984 Pair on an ox-cart.
Height 9 cm, length 11.7 cm, width 4.9 cm. Formerly Chesterman Collection with
GR.15.1984. Fourteenth–thirteenth century BC (Mycenaean culture
based on the Greek mainland), provenances unknown.

Sculptures were made in marble from the Neolithic Period (no. 1), but there was also a very long tradition of manufacturing terracotta figurines, which were popular on the Greek mainland from the Late Bronze Age (1550–1100 BC) onwards. These tend to be small, and early on were made by hand in clay and painted. Organic material such as straw was added to minimise shrinkage when they were fired. The figures, mostly representing females, have been found in settlements, but they were also deposited in sanctuaries and tombs. Some surely relate to the concern for fertility, but others, such as the complicated group here, were almost genre narrative scenes that related to the wish for a fecund crop.

The Phi-figure is so called because it resembles the Greek letter Φ, and traditionally is thought to represent a female with arms crossed at the breasts. Perhaps however it should be interpreted as the hands folded in front of the body. The figure is painted in vertical stripes, no doubt to show the drapery folds of a long garment bound at the hips. She was made as a single rod of clay which is flattened at the trunk of the figure, the head is pinched backwards and the face is beaked. Little dots of clay were applied for the eyes and breasts, and the base is splayed. The Psi-figure, resembling the Greek letter Ψ is thought to represent the worshipping female with arms raised. She is made in a similar way but wears additionally a hat and a garment which is diagonally striped.

Ploughing groups are not uncommon from this period, and here it seems we have not one but two figures applied to either side of a vertical post at the back of the ox. Clearly this is difficult to read visually, but must be a shorthand way of showing the figures riding behind the ox on a cart, reducing the likelihood of breakage by means of the shared contours, though this does not explain the risk taken to depict the reins. Perhaps they stand protected under a sunshade.

Further reading Higgins, *Greek Terracottas*, pp. 13ff.

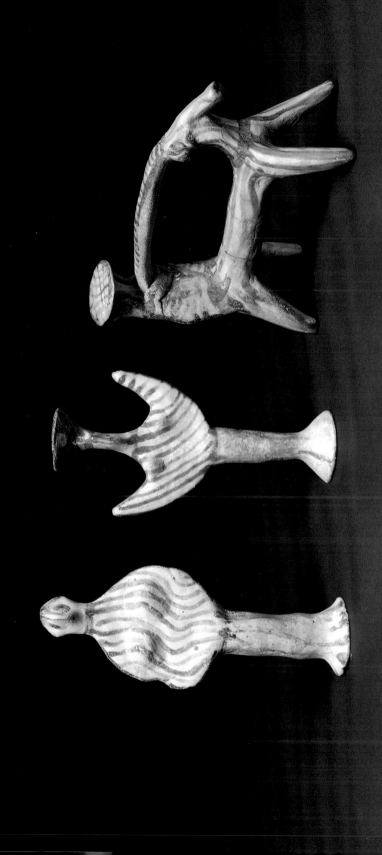

CYPRIOT MODEL GROUP

—

TERRACOTTA
GR.5w.1939.'Comb'. Red polished. Length 13.3 cm, width 7.2 cm. GR.5x.1939
'Comb'. Black polished. Length 9.7 cm, width 5.7 cm. Both Early Cypriot I or Early
Early Cypriot II, from Tomb 121, Vounous, Cyprus. GR.5t.1939 Hunting knife. Red
polished. Length 18.2cm, width 5.2 cm. GR.5u.1939. Scabbard. Black polished. Length
23.6 cm, width 5.3 cm. Both early Cypriot I, from Tomb 145, Vounous, Cyprus. Given
by J. R. Stewart (excavator). C. twenty-second century BC (Early Cypriot I–II).

The island of Cyprus, inhabited as early as 7000 BC, underwent a major and sophisticated change in the mid third millennium BC, possibly due to the arrival of Anatolians. Rich in copper mines, the Cypriots began to manufacture metalwork in specific areas (c. 2500 BC). It took several hundred years (1,600) before they began to widen their contacts and to trade with Western Asiatics, Egyptians and Greeks (no. 21).

As with most ancient cultures, the Cypriots believed in the magical metaphor. Thus models of objects of daily life, made in terracotta and often on a miniature scale, were placed in the tomb to represent the actual objects. In gathering material for the Hereafter, the family of the deceased saw fit to include a hunting knife and sheath in one tomb and comb-like objects in another. The knife imitates an actual cast and hammered blade with central ridge, the hilt equipped with sloping guards probably imitates wooden construction, and the sheath was, no doubt, leather. The combs, or brushes, are thought by some to be abstract figurines of pregnant females in pleated skirts. Undoubtedly, some have more pronounced human features on the 'handles', but even a mundane object such as a comb, lacking complicated fertility associations, was possibly considered a crucial piece of equipment for the deceased.

These implements were hand-made in terracotta and decorated by linear incision which was then filled with a white paste for tonal relief. It can be surmised that these were humble models of actual objects made of more noble materials – and therefore represented a 'burial economy'.

Further reading Karageorghis, Coroplastic Art, cat. nos. A 5–6, Hb 1, Hc 1, pls. XIX, LXI–LXII; D. Morris, The Art of Ancient Cyprus (London, 1985), pp. 138–141, 256–260.

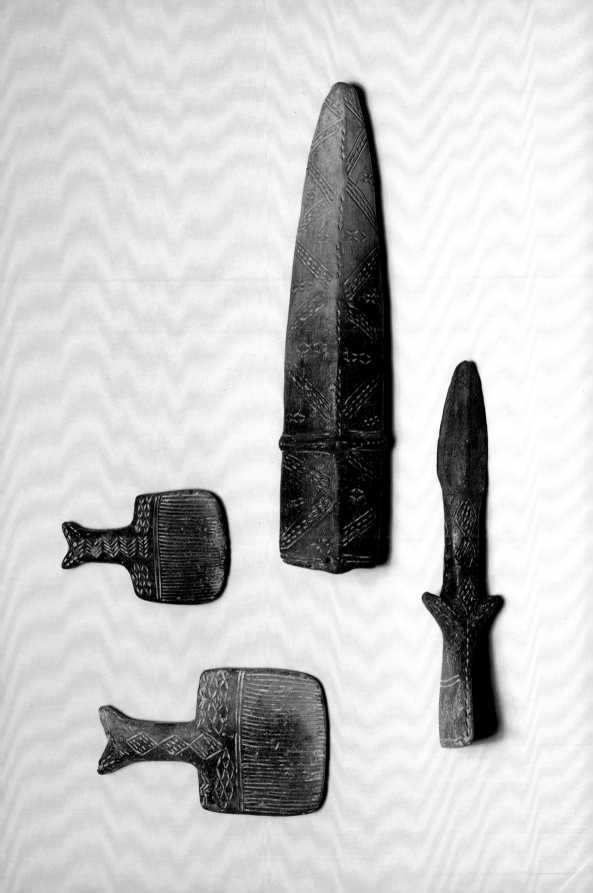

6

CORINTHIAN WARE

—

GR.13.1952 *Pyxis. Height 11.9 cm.* GR.1.1951 *Alabastron with
cock and snake. Height 26.3 cm. Bequeathed by C. H. Swainson.* GR.21.1929
*Lekanis with siren and lions. Height 15.8 cm, diameter 21.0 cm. Given by the Friends
of the Fitzwilliam Museum.* GR.2.1903 *Owl scent bottle. Height 6.7 cm, length 6.0 cm,
width 4.4 cm. From a tomb at Megara. Given by Professor R. C. Bosanquet.* GR.1.1936
Alabastron with Artemis and swans. Height 7.5 cm. By the Typhon Painter. GR.1.1929
Aryballos with animal chase. Height 5.6 cm. GR.7.1926 *Cup with siren, sphinx, animal
frieze. Height 8.5 cm, diameter 10.0 cm. By the Bird Frieze Painter.* GR.3.1963 *Aryballos
with scale pattern. Height 7.4 cm. Given with the last two by W. Lamb.* GR.59.1896
*Corinthian squat oinochoe with horsemen and two confronting figures.
Height 17.0 cm, base diameter 15.4 cm. By the Dodwell Painter.
Date range 680–550 BC.*

Following the Dark Ages (1100–900 BC), there was increasing contact between Greece and the east during the seventh century BC. This resulted in new graphic impulses which were immediately applied to Greek pottery, particularly examples manufactured at Corinth. These vessels, each of which conforms to a distinctive shape and modern name (*pyxis* for a small round lidded container, *oinochoe* for a vessel with a trefoil lip, and so on), were decorated in the black-figure style on the buff clay of the region, which lacked iron oxides.

The pots show highly disciplined zones of decoration, ornamental ones alternating with figural ones of eastern inspiration. However, the approach is not copy-cat, as the human figures could appear in profile view, unlike the eastern examples, and wearing Greek dress. Thus eastern lions can follow a procession of Greek mounted horsemen, and eastern winged lion-sphinxes can flank the Greek bird-woman siren. In addition to many hybrid animals shown in zones, there are animal chases and elaborate ornamental friezes. Figural zones are also punctuated by rosettes and other dot and linear motifs in the negative spaces to dizzying effect. This style of pottery which Corinth pioneered and marketed widely, started out as a miniaturist one called 'Protocorinthian' and developed into a Ripe Animal style. The pottery was so popular that other centres started producing imitation Corinthian ware, particularly in Etruria (no. 18).

Further reading Cook, *Painted Pottery*, pp. 46ff.; Payne, *Necrocorinthia*, pp. 16ff.

DEAD HARE

GR.1.1925 Terracotta scent bottle.
Height 6.7 cm, length 21.3 cm, width 4.7 cm.
Ears, front paws and tail restored. Sixth century BC, provenance unknown,
possibly Corinthian or east Greek. Given by the Friends of
the Fitzwilliam Museum.

To this day scents are bottled in small decorative vessels, usually with small necks to minimise spillage or evaporation. This moulded scent bottle in the form of a dead hare was a luxury item produced either in Corinth (no. 6) or in east Greece. The origin of such figural vases is uncertain but they were popular in both areas, and, like Corinthian ware, were imitated further afield in Etruria (no. 18), where for a long time this vessel was thought to have been manufactured. Unlike some of the careless imitations of Corinthian ware, this is a superb example of good potting and painting, as in the ware produced in east Greece. It is not clear of course whether the contents were actually imported or locally produced and specially bottled. The bottle could have rested on its flattened belly or it might have been hung from the front paws. In any case its contents would have been held in place by a stopper.

So-called 'plastic' or figural vases in the form of animals, which included boars, ducks, deer, eagles and swans, became popular in the early sixth century BC. The hare was well regarded because of its speed, its unlimited fertility, and its alertness even when asleep. It was considered a choice meat, hunted, also with the aid of dogs, or netted, but it also had medicinal value in many illnesses, in addition to its erotic associations. Perhaps it is this latter role which made the hare especially suitable as a scent container.

Further reading C. M. Robertson, 'A Group of Plastic Vases', JHS, 58 (1938), 41–50; Higgins, *Plastic Vases*, cat. nos. 1687–1688; J. Ducat, *Les vases plastiques Rhodiens archaïques en terre cuite* (Paris, 1966), pp. 131–132; M. Maximova, *Les vases plastiques dans l'antiquité* (Paris, 1929), ch. 7.

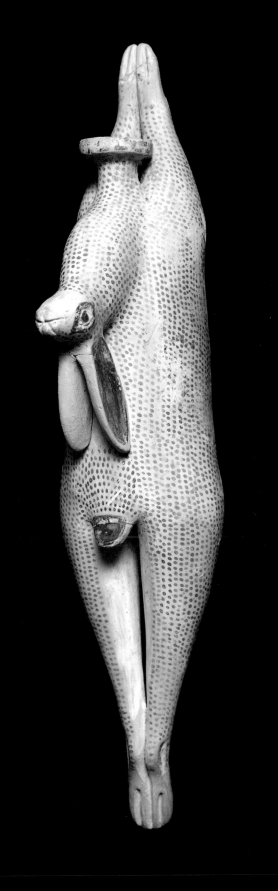

IVORY WOMAN

—

GR.63a.1905 *With traces of gold leaf.*
Height 6.5 cm, width 1.3 cm, depth 1.4 cm. C. 620–600 BC.
From Ephesos, purchased from A. O. van Lennep.

A remarkable archaic edifice was built to the goddess Artemis (no. 30) at ancient Ephesos where Greeks, Phoenicians and nomadic Cimmerians from Asia Minor evidently worshipped together from the seventh century BC onwards, as is evidenced by the votive dedications there. This minute female figure carved in ivory is thought to come from the sanctuary. Mostly derived from hippopotamus teeth and traded from Egypt and Syria, ivory was regarded as a luxury material and was certainly worthy of divine dedication.

As in the case of many early votive images without distinctive attributes (nos. 9, 12), it is unclear whether this figure represents the virgin goddess Artemis, mistress of animals, her priestess, or a female dedicant. Minute in size and compactly carved, the figure is in a static frontal pose, common for female images of the period throughout the ancient world. Attention is focussed on her overly large wide open eyes. She is dressed in the Greek sleeved *chiton*-under-tunic which is girt at the waist. A crisscross cap, seemingly embroidered, is her only adornment, and this may be the key to the ethnicity of the dedicant. Hollowed out underneath, the figure may have been the head of a dress pin, as several in different materials with a variety of types of heads were found at the site.

According to surviving correspondence this ivory figure was possibly spirited away from the excavations run by the British Museum and sold to the Fitzwilliam. Disappointed by not receiving 'a good haul' of the finds, the British Museum appealed to the Fitzwilliam's sense of fairness and asked to have the ivory in an equitable trade. The unrecorded response seemingly esteemed the ivory above a trade and caused further disappointment.

Further reading C. Smith, in D. G. Hogarth, *Excavations at Ephesus. The Archaic Artemision* (London, 1908), pp. 155ff.; P. Jacobsthal, *JHS*, 71 (1951), 93, pl. XXXVI a, b; R. D. Barnett, *Ancient Ivories in the Middle East* (Jerusalem, 1982), p. 59, pl. 57 c, d; A. Bammer, in J. Lesley Fitton, ed., *Ivory and the Eastern Mediterranean from the Bronze Age to the Hellenistic Period* = British Museum Occasional Paper 85 (London, 1992), pp. 185ff.

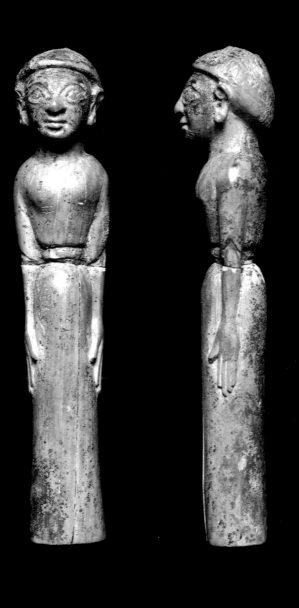

9

BOEOTIAN FIGURES

—

TERRACOTTA, HAND-MADE AND PAINTED.
GR.31.1984 Female. Height 16 cm. GR.32.1984 Female. Height 9.5 cm.
GR.29.1980 Female wearing pendant. Height 15.2 cm. Given by Mr and Mrs A. H.
Laurie. GR.114e.1908 Female. Height 24.3 cm. GR.114h.1908 Female wearing
pendant. Height 17.2 cm. GR.33.1984 Squatting male or possibly monkey.
Height 7.5 cm. Right foreleg restored. GR.114d.1908 Horse and rider.
Height 12.4 cm. Boeotian production, c. 600–550 BC.

The Greeks were producing monumental marble sculpture in the sixth century BC, but terracotta continued to have great appeal as an inexpensive, malleable and portable material which suited small-scale statuary, whether votive (deposited in temples or at cult sites) or funerary (deposited in tombs). Ultimately the significance of the figure was the important factor and not simply the medium. We can see that Greek artisans could certainly paint very precise and beautiful figures on their pottery (no. 6) and so we must presume that these plank-like figures with pinched beak-like faces were intentionally stylised into this abstract form. The Boeotia which gives the terracottas their name lies to the north of Athens. They are characterised by their buff clay and distinctive simplified forms and painted decoration. The females are shown wearing long tresses, high headdress (polos), and long patterned garments, presumably imitating woven patterns in different colours. Some wear pomegranate amulets around their neck, which is evidence perhaps that these are votive images of women hoping to secure fertility in this life or in the next. Whereas the females stand or are regally enthroned, creating uncertainty about their purpose, the males are shown in more varied positions, at toil or on horseback, suggesting that they are mortals.

The figures were simply modelled by hand, and projecting elements were added separately. Sometimes the faces were not pinched into shape but moulded (as with the central figure here). The bases were left hollow or with vent holes for the air to escape during kiln firing. The statuettes were painted with glaze and fired under three different conditions. In about 550 BC the procedure was altered slightly so that a white ground covered the figures before firing and they were painted afterwards with a more varied palette.

Further reading Higgins, *Greek Terracottas*, pp. 45ff.; Higgins, *British Museum*, cat. nos. 203ff.; M. Szabó, *Archaic Terracottas of Boeotia* (Rome, 1994), ch. 4.

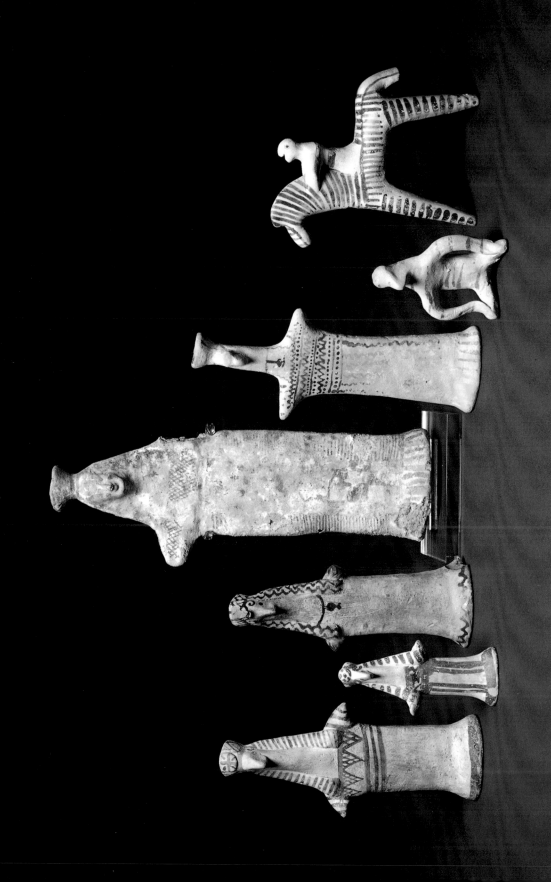

A BRONZE HOARD

—

GR.4.1932 *Ploughman. Height 5.5 cm.* GR.13.1904 *Dog (?)* GR.15.1904
Grazing deer. Length 9 cm. GR.11.1904 *Stoat. Length 9.5 cm.* GR.12.1904 *Dog (?).*
Length 7.2 cm. GR.10.1904 *Sheep. Length 6 cm.* GR.9.1904 *She-goat. Length 6 cm.*
GR.6.1932 *Bull. Length 8.7 cm. Sixth-century* BC. *From Cesme, near Izmir.*
1904 numbers McClean Bequest, 1932 numbers J. Duncan Bequest.

Part of a larger group of bronze figures scattered throughout a number of public collections, this group includes a peculiar ploughman along with domestic and wild animals. The wider group includes a total of four (two in the Fitzwilliam) such ploughmen, each with left hand on the plough handle, with two oxen, one forward, and one returning. Perhaps the arrangement is meant to telescope the course of the plough in both directions within the field. The wider group also contains mythical figures such as centaurs and mermen and pairs of knife combatants, and a number of domestic and wild animals, and marine life.

The figures are modelled as if frozen in their characteristic movements in the field. Thus the dogs are advancing, tails up and mouths open, whereas the deer quietly grazes, the sheep and goat pause with head up and turned sideways, and the bull has lowered his head to continue grazing. Observation of the particular is evident in the ploughmen, who are bearded and possibly bald. The group shows a coherent method of solid cast manufacture and the figures display a similar approach to style, datable to the early sixth century BC. It is unlikely that these are derived from a foundry since it was not usual working practice in antiquity to produce large stocks of goods. The scenes of ploughing and fighting, and the mythical figures, lead one to believe that the group was a funerary or more likely a votive deposit meant to elicit fertility benefits. Possibly the group was connected with the eastern worship of the mother goddess, Cybele, who was a fertility deity and was assimilated by the more western Greeks. The group demonstrates the ability to observe detail and to record both the momentary for the individual and the narrative group at a very early period.

Further reading D. E. L. Haynes, 'A Group of East Greek Bronzes', JHS, 72 (1952), 74–80; Haynes, *Technique*, ch. 2.

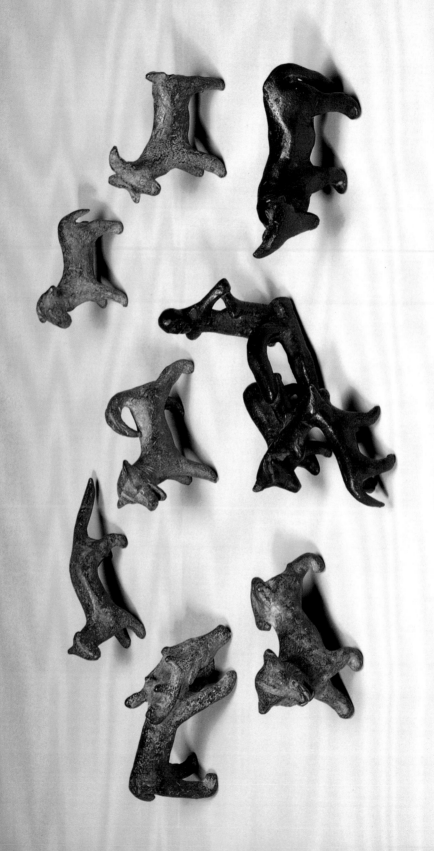

HELMET SCENT BOTTLE

—

GR.15.1864 *Copper alloy.*
Height 6.3 cm, width 4.3 cm, depth 7.5 cm.
C. 540–530 BC. Purchased by Col. W. M. Leake at
Pyrgos, west of Olympia, in Elis (Peloponnese).

Ancient scent bottles are preserved in all sorts of shapes, among them examples imitating animals (nos. 6, 7, 18) and, here, even a helmeted head. The actual metal Corinthian helmet, often illustrated on Corinthian pots, was hammered into shape from a single piece with cut-away sections for the eyes and mouth. Its introduction no doubt afforded soldiers greater protection and ease of wear than the composite forerunner of such helmets, albeit at the same time restricting their vision and hearing on the battlefield. It was momentous enough to be translated into a scent bottle, sometimes produced in painted ceramic, and here more appropriately in copper alloy. The vessel opening is cleverly positioned on top where one expects to find an attachment for plumes on actual helmets. From about 700 BC, the Greeks no longer buried their armour with their dead warriors, but became accustomed to dedicating it to a sanctuary, as they did one-tenth of the spoils of war. Smaller-scale dedications are known, but here the incised inscription above the helmet ridge tells us that 'Koios made this', and not specifically that it is a dedication.

This lively vessel was cast, and the flat base (now lost) was separately soldered in place, presumably with lead. The perforated eyes were once inlaid in another contrasting material, perhaps silver. The vessel was further decorated by incision and punching with the customary petals around the lip of the spout, a dolphin on the handle-plate, two confronting snakes on the forehead and a striding boar on either cheek-piece. A related actual helmet found on an ancient battlefield, and the style of the inscription here, allow us to date this piece to about 540–530 BC, when it was made by Koios, probably from Elis.

Further reading A. M. Snodgrass, *Arms and Armour of the Greeks* (London, 1967/ Ithaca, 1976), pp. 48ff.; A. M. Snodgrass, in F. G. Maier, *Alt Paphos auf Cypern* = Trierer Winckelmannsprogramm 6 (Mainz, 1985), pp. 45–49.

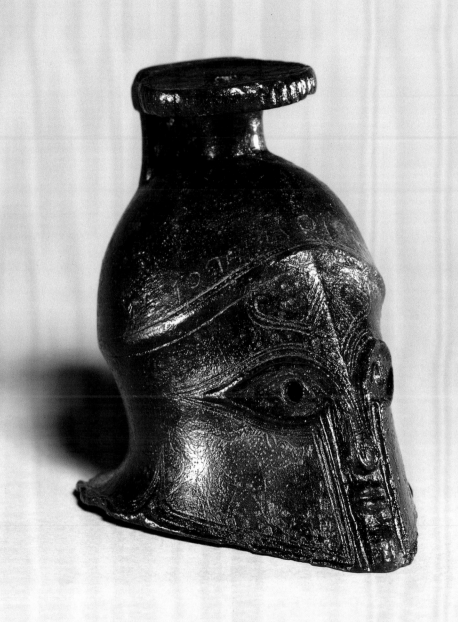

WOMAN WITH LOTUS

—

GR.10.1928 *Copper alloy.*
Height 13.5 cm. Sixth-century BC, *possibly from Attica, Greece.*
Given by Sir Alfred and Lady Chester Beatty.

This splendid image is of a young woman who stands barefoot on a square plinth with her left leg slightly advanced. Her arms are extended before her, holding a lotus bud in her left hand, but without preserved attribute in the lowered right. She wears a high hollow headdress (*polos*) stamped with a decorative frieze of palmettes over a thick crimped single tress of hair that is also bound by a fillet, and she is dressed in a heavy woollen *peplos* with a cape-like overfall (*apoptygma*) which covers her upper arms. Her garment is belted at the waist and is arranged in two large vertical trimmed folds at the sides with four small pleats at the front.

It is often difficult to distinguish between the archaic images of votaries (worshippers), dead or alive, and deities (nos. 8, 9); the *polos*-headdress could be worn by either (nos. 8, 12). However, perhaps the closed lotus is significant. The lotus which opens at dawn and closes at dusk may suggest a fertility wish and thus identify the woman as an unmarried virgin. On the other hand, it may suggest a desire for revivification and allude to a dead maiden whose image was to be deposited as a funerary votive in the sanctuary of a goddess.

Technique and scale, proportions, style and pose are all useful dating criteria. The figure is solid cast, but with arms separately cast and attached. The face, with its high forehead, 'popping eyeballs', squared jaw with recessive chin and benign smile is characteristic of the Archaic Period. These features, together with the high columnar neck and the concealed figural volumes, help to suggest a date of about 540 BC. The form of the drapery points to the region of Attica.

Further reading Ilaria Romeo, 'La fanciulla con il loto. Una statuetta bronzea a Cambridge e l'iconografia delle korai arcaiche', *Atti Della Accademia Nazionale dei Lincei*, 5 (1994), 157–171; Lamb, *Bronzes*, pp. 87ff.; J. Charbonneaux, *Greek Bronzes*, trans. K. Watson (London, 1962), pp. 87ff.; For the *peplos*-garment, see B. S. Ridgway, *GettyMusJ*, 12 (1984), 30ff.

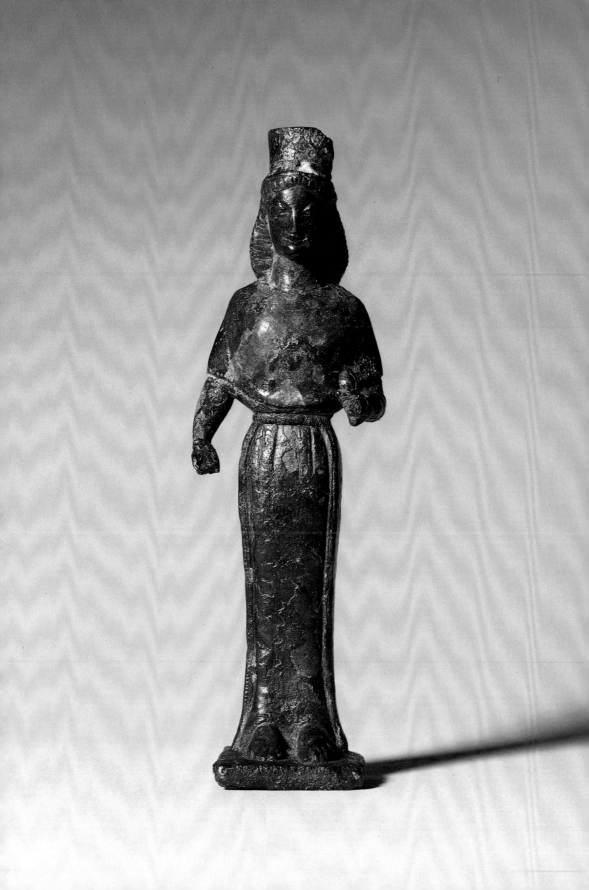

THE BANQUETING DIONYSOS

—

GR.27.1864 *Black-figure neck amphora.*
Height 30.7 cm, width 21.5 cm. Manner of the Lysippides Painter,
c. 530–520 BC. Attic production, from Vulci,
formerly Leake Collection.

The ubiquitous Greek wine jars and drinking cups manufactured in Attica, but found all over the Mediterranean, reveal much about culture, beliefs, artistic development and trade. The red ground of the iron-rich Attic soil was the 'canvas' for the figures and decorative motifs executed in black glaze with details added by means of incision, or red and white pigment, and fired under special conditions, which gave the name to black-figure vases. Bands of ornamental friezes decorated parts of the pots, such as the lotus and palmettes within cable borders on the neck of the vessel, and the rays above its foot. The drawing of the figures on Greek vases is distinctive and diagnostic, so that specialists can distinguish between individual artists and those working in the manner of another, and date them to within twenty-five years of their production.

In the present vessel, classed as a neck amphora because of the position of the two handles, we see a reflection of the hand of the vase painter who worked with the potter, Lysippides. Dating from the late sixth century BC, this scene depicts the bearded and wreathed god of wine, Dionysos, lying with his pale-skinned consort Ariadne, and drinking on a banqueting couch. They are shown in disarray, half-naked but also partly covered in richly patterned and embroidered garments. Attended by a naked youth who fetches wine, they are also flanked by dancing satyrs, each with a music-making maenad above his head. A dog feasting on a bone under the couch completes the scene of debauched abandon. A dancing procession of aged silens appear on the less important B-side of the vessel. It has been suggested that such scenes relate staged re-enactments of myths.

Further reading CVA 6:1, pls. 10, 1 and 23, 2; ABV 259,17; T. H. Carpenter, *Dionysian Imagery in Archaic Greek Art* (Oxford, 1986), pp. 91, 114; G. Hedreen, *Silens in Attic Black Figure Vase-Painting; Myth and Performance* (Ann Arbor, 1992), pp. 138ff; J. D. Beazley, *The Development of Attic Black-figure* (1951), revd edn (Berkeley, 1986), ch. 7.

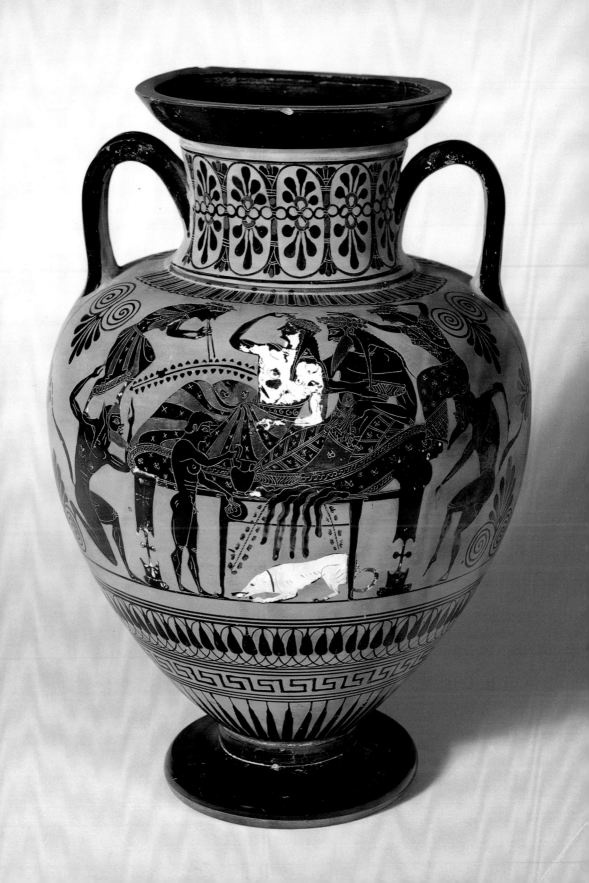

AN EARLY ATHENA

—

GR.87.1937 *Terracotta with pigment. Height 13 cm,*
width 7.1 cm, depth 6.7 cm. C. 490 BC. Attic production.
Bequeathed by C. S. Ricketts and C. H. Shannon.

The ancient 'coroplast', or maker of terracotta figures, produced images of deities, votaries, animals and three-dimensional genre scenes. These were deposited in sanctuaries and graves or were simply toys. Various regional workshops enjoyed a privileged position in the manufactured export market at different periods: the east Greek in the seventh century BC, followed by the Cypriot later in the century (no. 22), followed by east Greek again, Boeotian (no. 9) and Attic. Some centres imitated the coroplastic and ceramic styles of others (no. 18). Subject, style, type of fabric and approach to manufacture, combined, help scholars to identify the place of production.

Excavations on the Athenian acropolis uncovered hundreds of terracottas depicting an enthroned goddess, sometimes shown with an *aegis* on the breast (no. 33), the attribute of the goddess Athena. The figure shown here is generic in her pose, seated and fully enveloped by her *chiton*-dress, which is only evident at the hem on the projecting base. Nevertheless, the fabric of the clay and the style clearly identify this as of Attic manufacture and therefore most probably Athena, goddess of Athens. The blurred or *sfumato* modelling of the face of the goddess, typical of these mass-production Athenian dedications, is relieved by the precision of the rows of snail curls below her *stephane*-head-dress and the elegant palmettes on the wings of the throne. The goddess, characteristically for the period, is further covered by the *himation*-shawl which is also worn over the head. The figure, covered with a white wash, originally blazed with colour; her dress was painted blue, her hair black and throne red. It is possible that facial details were given greater definition with pigment.

These types of terracotta figures were generally moulded from the front, but were solid and flat at the back. The lower part was hollowed out after moulding. First attested in about 520 BC, the type lasted until about 450 BC.

Further reading Higgins, *Greek Terracottas*, pp. 71ff.; Higgins, *British Museum*, cat. nos. 171ff.; S. Casson and D. Brooke, *Catalogue of the Acropolis Museum* II (Cambridge, 1921), pp. 317ff.

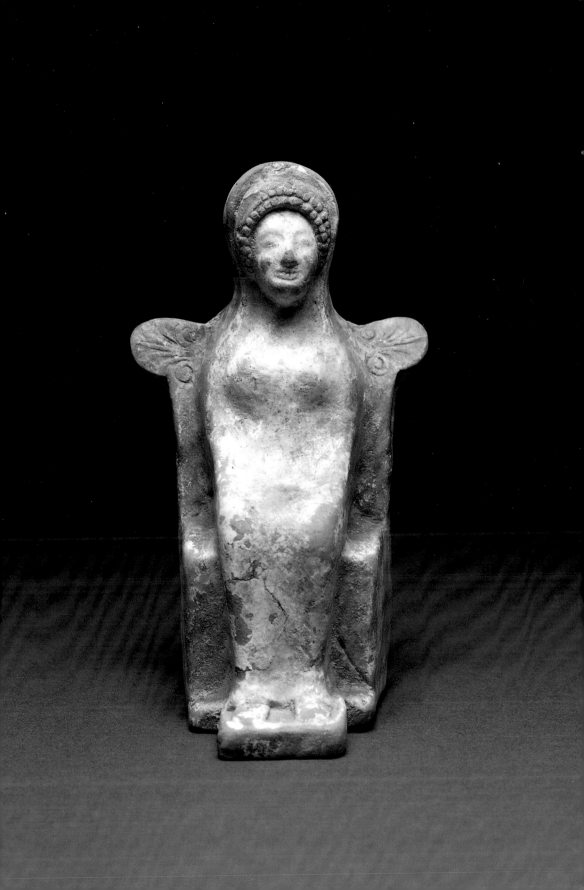

BRONZE JEWELLERY

—

GR.1.1972 *Belt. Height 13.5 cm, width 30.8 cm.*
GR.B.19 *Spectacle fibula (brooch). Diameter of spirals 5.4 cm; length 13.1 cm.*
GR.16.1864 *Spiral armlet. Length 12–15 cm, diameter 6.5–8.5 cm.*
Formerly Col. W. M. Leake Collection. Provenance unknown,
Italian (?), eighth–seventh century BC.

When we think of jewellery, we tend to think in terms of precious metal. However, in the Bronze and Iron Ages, most jewellery was made of base metal. Massive rods of copper alloy coiled into double spirals or armbands made their appearance in Europe in the Early Bronze Age (c. 1700 BC). The Iron Age (eighth century BC) armlet shown here was made by rolling and hammering a single sheet of copper alloy into a rod which was then coiled twenty-eight times, but with a widening diameter to accommodate the upper arm. The ends were turned into small decorative curls. Before coiling the rod, the smith or jeweller scored clusters of decorative lines which pass entirely around it.

The dress pin, or 'spectacle' *fibula*, which resembles a pair of modern eye glasses, is attested from the Early Iron Age all over Europe, as far south as northern Greece and westward through northern Italy. This type of developed fastener co-existed with the simpler toggle or straight pin which could be held in place by a length of cord. The present *fibula* is composed of two separate rods of alloyed copper of equal length coiled thirteen times and fixed to the ancient equivalent of a safety pin. The belt, decorated with bosses and incised decoration was once secured at the back by a leather strip. Its tapered form can perhaps be seen on a stylised figure on a pot of the period (no. 16).

Further reading J. Alexander, AJA, 69 (1965), 9ff., ills. 2ff.; M. Comstock and C. Vermeule, *Greek, Etruscan and Roman Bronzes in the Museum of Fine Arts Boston* (Boston, 1971), cat. nos. 268, 335; H. Donder, *Die Fibeln: Katalog der Sammlung antiken Kleinkunst des Archäologischen Instituts der Universität Heidelberg* II (Mainz, 1994), pp. 76ff. H. Hencken, *Tarquinia, Villanovans and Early Etruscans* I (Cambridge, 1968), pp. 167, 271, 273; P. Jacobsthal, *Greek Pins and their Connections with Europe and Asia* (Oxford, 1965), pp. 166ff.

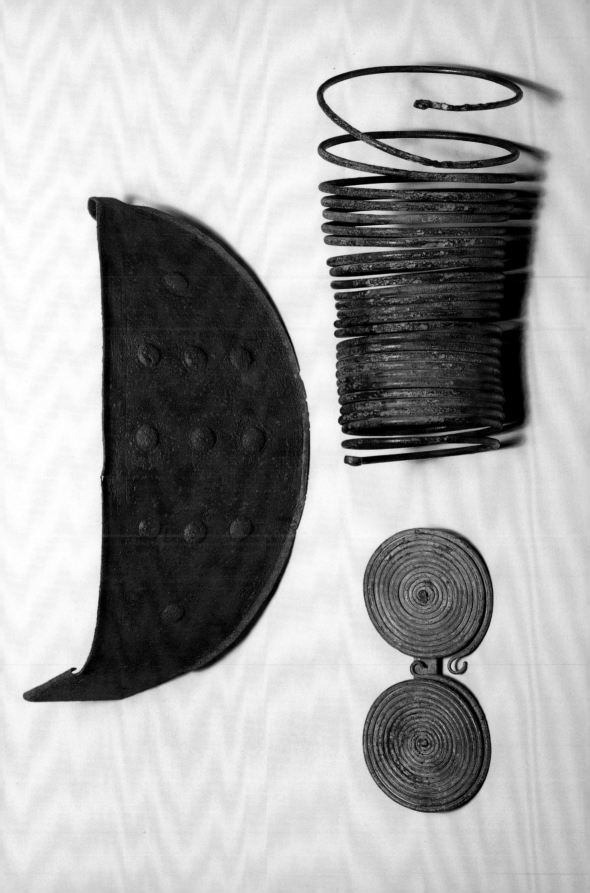

ETRUSCAN 'SKYPHOS'-CUP

—

GR.17.1952 Impasto ware, incisions filled with yellow ochre.
Height 8.3 cm, diameter 9.8 cm. Seventh century BC, c. 650–625 BC.
Etruscan (Falerian) manufacture, provenance unknown. Formerly Barrett Collection,
transferred from Museum of Archaeology and Anthropology, Cambridge.

Pre- and early Etruscan pottery of Iron Age northern Italy (ninth century BC onwards) was produced in a wonderful variety of shapes, often imitating Greek vessels. The present wheel-thrown cup was produced in impasto ware, a kind of unrefined mixed clay which was thinned then covered in watery clay slip, burnished and finally fired. These pots were often decorated with linear patterns in horizontal zones, more rarely with figures. The present example is a fairly thin-walled *skyphos*-drinking cup, which broadly copies the Greek examples but which also seems to be derived from metal prototypes. Thus, the halved melon shaped vessel, with vertical indentations, recalls hammered and fluted metal vessels. The robust handles would have been cast and mechanically attached in metal.

The figure, presumably male, is shown in a delightfully abstract form with a beaked and crested head, triangular dot-decorated torso and curvilinear legs. The man is shown in an aspective view with the planes of the various body parts rotated frontally in the case of the upper trunk and arms, and in profile for the head and legs. The base of the triangular trunk acts as a shared contour as if for the bottom edge of the ovoid belt customarily worn during the period (no. 15). The feet are shown smaller than the hands, almost as if due to perspective, as they are not on the same plane but on the underside of the vessel. An identical figure appears on the opposite side of the cup, and a fish is shown under each handle. The incised decoration was carried out when the pot was leathery hard before firing, and was finally filled with yellow ochre. The vessel may originate in Faleria in south Etruria, where a few complete vessels of similar style have been found. The connection between the figure and the fish is unclear.

Further reading A. Cozza and A. Pasqui, 'Degli scavi di Antichità nel Territorio Falisco', *MonAnt*, 4 (1894) pp. 270ff., esp. 290–291; L. A. Holland, *The Faliscans in Prehistoric Times* (Rome, 1925), pp. 93ff.; T. W. Potter, *A Faliscan Town in South Etruria: Excavations at Narce 1966–71* (London, 1976), pp. 263ff.

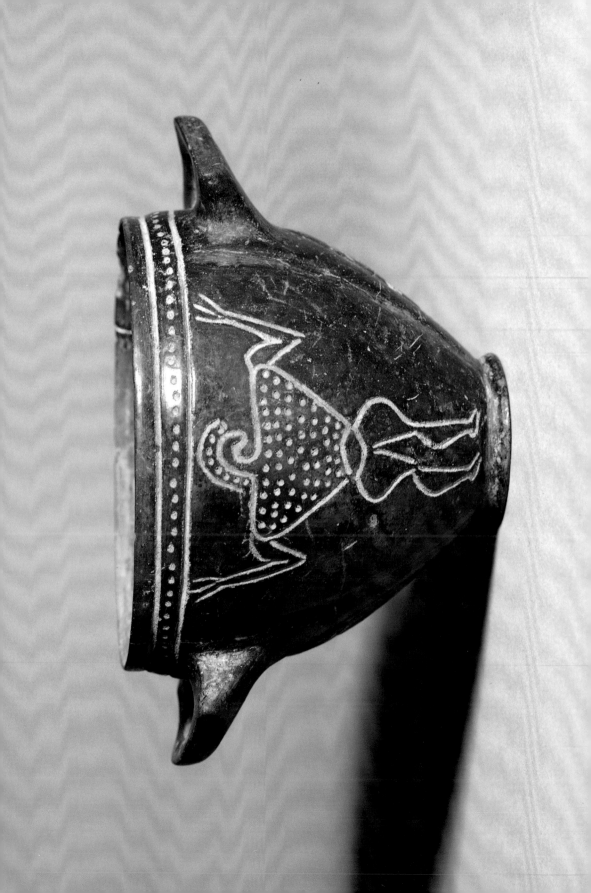

HORSE FINIAL

—

GR.1.1952 Copper alloy.
Height 14 cm, width 8.0 cm, depth 1.6 cm.
Sixth-fifth century BC, Etruscan (Vulcan production).
Given by Dr Winifred Lamb.

The Etruscans, like their Greek counterparts, often made their vessels of hammered sheet metal, but adorned them with cast pieces. The present ornament comes from the top of a tripod stand, composed of cast decorative pieces, which once supported a round hammered brazier. The Greek equivalent was used for liquids and not burnt kohl. The forepart of antithetical horses on an arched and collared rod (forming the apex of paired tripod struts) appears above an openwork lyre-shaped decoration of palmettes springing from a meandering tendril. The horse heads are modelled fully in the round as they protruded above the bottom rim of the curved brazier. Originally, the tripod was made up of three such decorative finials, and a second one, perhaps from the same stand, is now in the Ashmolean Museum in Oxford. The horses, shown with legs abbreviated and bent in order to accommodate them both, have highly stylised manes tufted into triangular sections. This ornament conforms to an Etruscan workshop type localised in Vulci. The Etruscans built up a prolific metalworking industry producing decorative elements for both everyday and ritual objects. Although the impulses were derived from Ionian Greece, the style was distinctively Etruscan. Similar openwork patterns also appear in Phoenician ivory carvings from the ancient Near East, adapted from Egyptian lotus friezes.

Despite the enormous effort devoted to the decorative casting, the Etruscans, like most ancients, did not solder but mechanically attached the elements, often harshly. Thus, they secured this ornament by driving nails into the backs of the horses' necks straight through the wall of the vessel.

Further reading K. A. Neugebauer in *AA*, 28–29 (1923/1924), 302ff.; K. A. Neugebauer, 'Archaische Vulcenter Bronzen', *JdI*, 58 (1943), esp. 210ff.; A. C. Brown, *Ancient Italy before the Romans* (Oxford, 1980), pp. 58ff.; Cleveland, *The Gods Delight*, pp. 178ff.

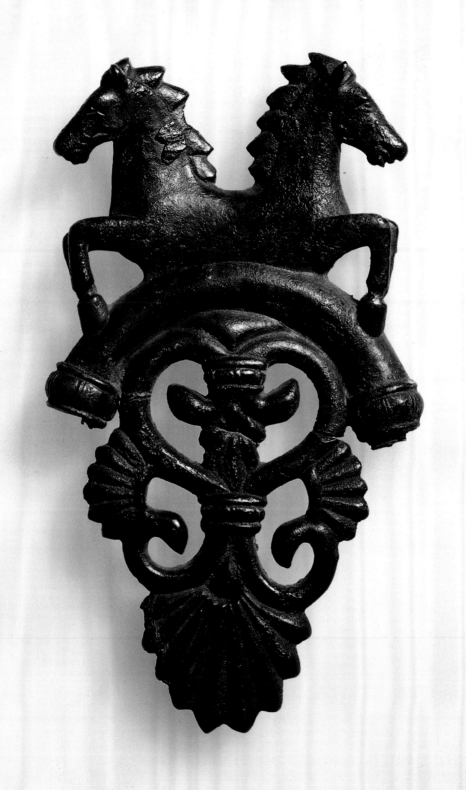

IMITATIONS OF CORINTHIAN WARE

—

GR.44.1896 *Boeotian (?) sack alabastron with swans and palmettes.*
Height 20.0 cm. Given by Professor R. C. Bosanquet. GR.38.1982 *Etruscan pyxis.*
Height 9.7 cm, diameter 11.3 cm. Given by the Wellcome Trustees. GR.3a.1924 *Etruscan*
swan vessel. Height 7.5 cm. GR.1.1931 *Etruscan cup with lions, sphinx, swan and siren.*
Height 14.8 cm. By the Fitzwilliam Painter, 580–550 BC. Given with the previous cup
by Winifred Lamb. GR.61.1896 *Etruscan sack alabastron. Height 6.5 cm.*
GR.60.1896 *Etruscan (Caere?) globular aryballos. Height 7.5 cm. Attributed to the*
Hercle Group. GR.63.1896 *Etruscan (Viterbo) pointed aryballos. Height 10.5 cm.*
Given with the previous two by H. Cope Caulfield.

In every society, people have aspired to own expensive luxury imports. Money
has not always matched aspirations and thus counterfeiting has occurred since
antiquity. Highly decorative pottery produced at Corinth in the northern Greek
Peloponnese was exported all over the Aegean (no. 6). Yet in places both far and
closer to home, workshops were generating copies of this ware, mostly for local
consumption. The copies range from almost indistinguishable examples to
caricatures of this style which incorporates animals, hybrid beasts and decora-
tive motifs, some of which are eastern in inspiration. On the whole, the fabric
of the ancient imitations is very telling. The clay in Etruria where workshops
flourished is muddier in tone, although like the clay of Corinth it lacks iron oxides.
Occasionally a thin slip was applied to the imitation vessels to lighten the clay.
Much of the imitation ware shown here has looser figural contours, with some
sloppy incision meant for delineation, and a consequent loose and dull appli-
cation of colours. The distinctive vase shapes of the imitations were often varied
slightly and the range was widened. Thus, the imitation cups produced in
northern Italy tend to be deeper than the Corinthian ones, and the proportions
of the *alabastron* (a type of flask with rounded base whose namesake prototype
was carved in alabaster from the east or marble from the west) differ, with a
thicker neck and flatter base. Some of the 'pseudo-Corinthian' ware might
have fooled the non-expert, whereas other pieces were surely known to be
copies, yet were still perceived as more desirable than the local ceramic styles.

Further reading Payne, *Necrocorinthia*, ch. 13, esp. pp. 188ff.; Cook, *Painted Pottery*, pp.
142ff.; G. Riccioni in D. and F. R. Ridgway (eds.), *Italy Before the Romans: The Iron Age,*
Orientalizing and Etruscan Periods (London, New York and San Francisco, 1979), pp. 265ff.

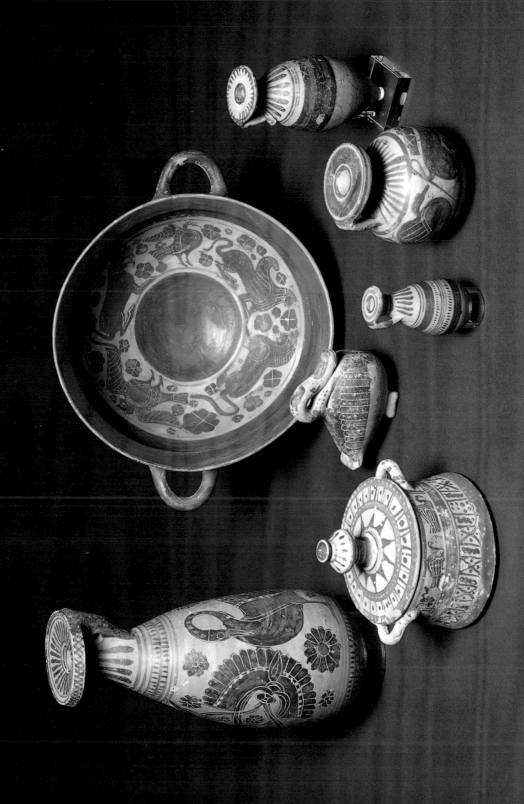

RITUAL 'PATERA'-VESSEL

—

GR.5.1925 *Copper alloy.*
Height 47 cm, diameter 27 cm, height of handle 20 cm.
Early fifth century BC. *South Italian manufacture (?), provenance unknown.*
Formerly Wyndham Cook Collection. Given by Dr Winifred Lamb.

Ritual offerings were proffered to deities in special, usually type-specific, vessels. This vessel is a particularly fine and well-preserved example of a shallow pan-like *patera*. Analogous in configuration to mirrors, which were usually supported by mainly draped maidens that stood upright, the archaic *patera* was almost invariably supported by a naked youth in this period, and was meant to lie flat when not in use. Nudity had heroising resonances in ancient Greece, and thus this choice of handle was especially suited to such a sacred object. The youth, wearing long crimped tresses favoured by the god Apollo, stands on a ram's head, which, in addition to being an appropriate animal for sacrifice, also served as a rounded decorative terminal (surviving on *patera* handles as the end of a fluted drum). An openwork crowning device, composed of a central palmette flanked by lotuses on a scrolled horizontal bar, forms the transition between figure and utensil.

The actual vessel was hammered into shape, and the handle was lost-wax-cast and riveted in place. The fine quality modelling was executed originally wholly in wax. The taut figure is shown with highly arched brows, upward-looking gaze and small mouth pulled in at the corners. The tripartite model-ling of the belly is especially set off by the chest, which is delineated in planes, and simple treatment of the arms. Indeed, it is the treatment of the belly which has suggested to some a south Italian provenance. Such vessels had a sixth century BC origin in the Greek Peloponnese, and were later manufactured in colonial Greek southern Italy before being imitated in Etruria further north. They survived, along with terracotta imitations, into the fourth century BC.

Further reading Lamb, *Bronzes*, p. 131, pl. 44d; G. Schneider-Herrmann, 'Apulische Schallengriffe verschiedenen Formen', *BABesch*, 37 (1962), 40–51; U. Jantzen, *Griechische Griffphialen* (Berlin, 1958); M. Gjödesen, 'Bronze Paterae with Anthropomorphous Handles', *ActaArch*, 15 (1944), 101ff.; J. R. Mertens, in *Getty, Small Bronze Sculpture*, pp. 85ff.

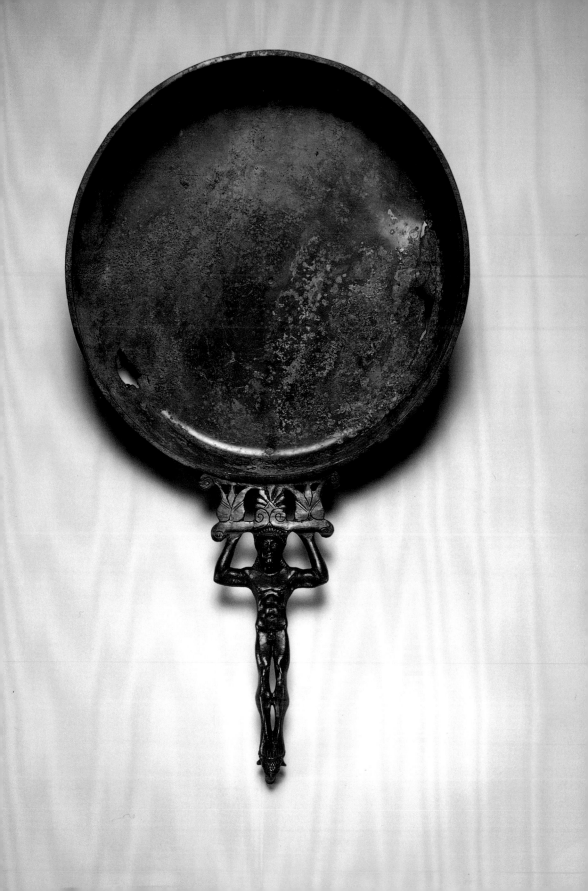

PROTECTIVE APPLIQUÉS

—

TERRACOTTA

GR.57.1887 *Gorgoneion. Height 6.5 cm.*
GR.56.1887 *River god. 4.5 cm. Both Campanian manufacture,*
from Naukratis, Egypt. Both given by the Egypt Exploration Fund.
GR.3a.1912 *River god. Height 4.5 cm. Campanian, provenance unknown.*
Bequeathed by C. B. Marlay. Early fifth century BC.

The ancients celebrated life-giving fresh water, and personified the concept of the river and its resulting abundance as the bearded man, Acheloos, with bull horns. According to myth, Herakles battled with Acheloos in order to create canals, and in so doing broke off one of his horns which was transformed into a cornucopia which Acheloos often holds. Early in the fifth century BC the disembodied mask-like head of Acheloos was used as an apotropaic image to ward off evil.

The head of Medusa, also called a gorgoneion, had a more sinister origin. Medusa was a terrifying female monster with boars' teeth, whose hair was composed of writhing snakes. Her head, cut off by the hero Perseus, turned men who gazed upon it into stone. Her blood both revived the dead and harmed men. Thus, the gorgoneion became a powerful apotropaic image which was also worn as a pendant by the deities Zeus and Athena.

Remarkably, the two mask appliqués of Acheloos came to the Museum from different sources fifteen years apart. Both were originally made in Campania, and one certainly found its way to a Greek trading city at Naukratis in Egypt where it was excavated, whereas its identical pair, possibly from Italy itself, found its way into a private collection and thence to the Museum. The gorgoneion (nos. 33, 45, 46) with the hair conventionalised into snail-like curls, with terrifying incisors and extended tongue, was also originally Campanian and also came from Naukratis. The painted appliqués were probably once attached to wooden coffins.

Further reading E. Schmidt, *Katalog der antiken Terrakotten* I (Mainz, 1994), cat. nos. 224–227; A. Levi, *Le terracotte figurate del Museo Nazionale di Napoli* (Florence, 1926), cat. nos 590, 595, figs. 108–109; J. R. Jannot, 'Achéloos, le taureau androcéphale et les masques cornus dans l'Étrurie archaïque', *Latomus*, 33 (1974), esp. 778ff.; LIMC I, 12ff.

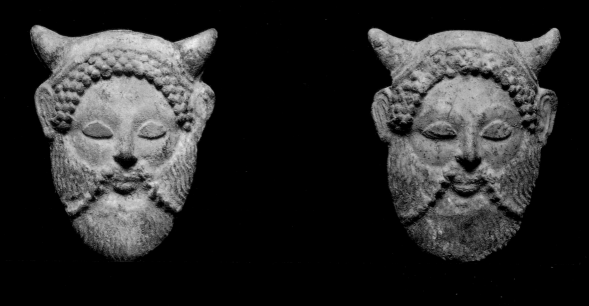
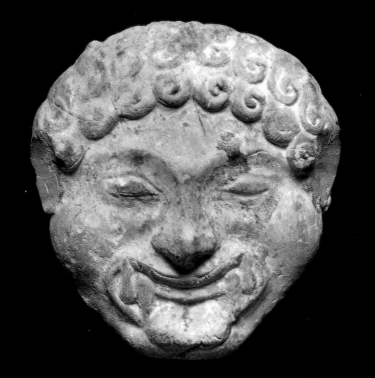

A CYPRIOT LADY

GR.151.1864 Copper alloy. Height: 13.8 cm, width 5.2 cm, depth 2.5 cm.
Seventh–sixth century BC. Cypriot manufacture, provenance unknown.
Formerly Col. W. M. Leake Collection.

As a rich source for copper, Cyprus became a focal trading centre for the Levantines (Phoenicians), the Anatolians and the Greeks in the Aegean during the Bronze Age (no. 5). The Phoenician traders plied the entire Mediterranean, trading as far west as Etruria in northern Italy and even Spain. There were sizeable expatriate communities of Phoenicians in Cyprus and it was no doubt largely through them that the Cypriots absorbed foreign artistic influences.

The exposure to Assyrian and Egyptian sculpture helped Cypriot craftsmen to begin to fashion bronze statuettes and to consider the leap towards more monumental statuary. In Egyptian art the female votary was almost always shown standing with legs together, wearing a long wig, a broad collar, and a long narrow seamless shift, through which the body was clearly modelled, and her left arm was usually raised to her chest to grip a lily sceptre. In this derivative solid-cast bronze (the Egyptian contemporary equivalent would be hollow), the figure is oddly proportioned, more lumpy and less symmetrical than actual Egyptian examples. The broad collar has been reduced to a two-strand choker, the thick shift is A-line in contour so that the bulk of the legs is not evident through the garment, and the wrong hand (according to Egyptian convention) is drawn up into an empty fist at the breast. It is evident that this was either never intended to be a copy of an Egyptian votary or it was derived second-hand from Egyptian prototypes. It should also be noted that about this time the Egyptians ceased to create images of female queens and votaries (certainly by 600 BC) until the time of Alexander the Great (332 BC). Sculptures probably still stood in temples, but the production of small-scale bronzes and hard stone sculptures of females had stopped, probably making the dissemination of the Egyptian ideal female outside Egypt more difficult. Likewise, Cypriot bronzes of females are rare in comparison with male figures, and mainly depict deities.

Further reading A. T. Reyes, 'The Anthropomorphic Bronze Statuettes of Archaic Idalion Cyprus,' BSA, 87 (1992), 243–257.

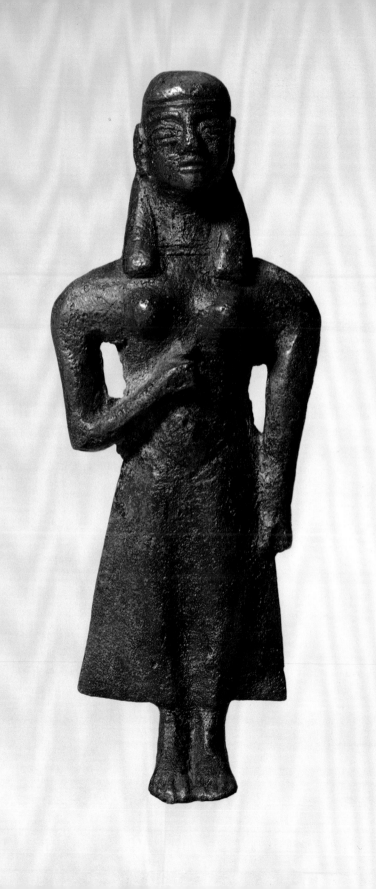

HELMETED MALE HEADS

—

TERRACOTTA

GR.22.1891 *Height 11.6 cm, width 9.6 cm.* GR.25.1890
Height 23.7 cm, width 12.1 cm. GR.11.1890 *Height 10.3 cm, width 7.2 cm.*
GR.9.1890 *Height 7.4 cm, width 4.8 cm. C. 600 BC. From Salamis, Cyprus.*
Given by the Cyprus Exploration Fund.

It was reported in antiquity that a Cypriot ruler swore an oath to provide fifty ships for the Trojan war. In the event he provided one and dedicated forty-nine others in terracotta to the Paphian sanctuary. Indeed the prolific output of terracotta sculpture from Cyprus, which ranges from figurines to heroic sizes of over four metres, brings this tale to mind.

Great numbers of large, alas fragmentary, and smaller-sized sculptures of 'helmeted' votaries bearing a sacrificial kid were dedicated at the sanctuary at Salamis. The men are youthful and beardless and eastern in appearance, with heavily rimmed eyes and bushy patterned or 'feathered' brows. They wear the *kidaris*-helmet, which is seemingly made of tooled leather and provided with a peak and ear flaps. This is almost a cross between the Egyptian White and Blue Crowns. Un-Egyptian are the ear flaps and the fact that the hairline of curls is depicted on the forehead. Some of these figures wear leech-shaped earrings painted yellow or red as here, to suggest gold.

These votary figures were normally mould-made and details such as the earflaps, eyebrows, etc., were added by hand before firing. Figures produced in eastern Cyprus, such as these, show more affinity with Egypt and Syria. This is especially true of the less numerous limestone figures which, however, show more variations. From the middle of the seventh century BC, Cypriot terracottas were exported and began to outdo the hitherto east Greek imports. Indeed, it is thanks to the well-stratified Cypriot votives deposited at the international sanctuary at Greek Samos that we can date these sculptures to about 600 BC.

Further reading E. Gjerstad, *Swedish Cypriot Expedition* IV:2 *The Cypro-Geometric, Cypro-Archaic and Cypro-Classical Periods* (Stockholm, 1948), pp. 105ff.; Karageorghis, *Coroplastic Art*, cat. nos. 98–99, pl. xxv:5–6; Budde and Nicholls, *Catalogue*, cat. no. 23; J. A. R. Munro and H. A. Tubbs, in JHS, 12 (1891), esp. 155ff.; A. Hermary, 'Les débuts de la grande plastique chypriote en terre cuite', in Vandenabeele and Laffineur, *Cypriote Terracottas*, pp. 139–147.

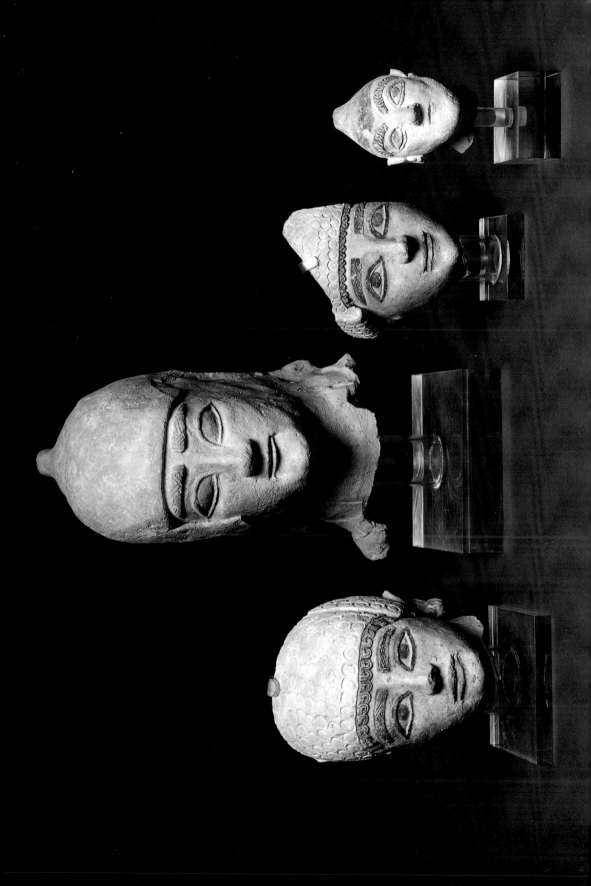

A BOAR WITH A CAKE

—

GR.34.1984 *Terracotta, hand-made,
white slip, with red and yellow pigment. Height 4.9 cm,
length 10.5 cm, width 2.7 cm. Early fifth century* BC.
*Boeotian manufacture, provenance unknown.
Formerly Chesterman Collection.*

It is hard to know why an animal might be moulded in the early fifth century BC. Was it meant as a toy, or did it have religious significance? The boar depicted here has been made by hand, not in a mould, and gratifyingly for a child, not on a plinth.

The boar has been captured in a momentary pose. He has paused for a moment to devour the cake which he holds in his mouth. This may be a toy, but on the other hand the cake may be significant. Some nine different types of cake have been identified from ancient texts, most of which were worthy of sacred rituals. Indeed, the small round cake here may be the *kolluva*-wheat-cake of antiquity made for rituals welcoming a new family member or slave. This was also the appropriate gift to the goddess Demeter who taught man the cultivation of cereals. Numerous miniature terracotta votive cakes were deposited at her sanctuary at Acrocorinth in the Peloponnese between the sixth and second centuries BC. Actual cakes made in the shape of animals especially suited to particular deities are also known to have been dedicated in antiquity. Indeed, the pig was known to be sacred to the goddess Demeter. It is therefore possible that the present boar is meant to reinforce the offering of the ritual cake which it has not quite devoured.

Further reading A. Brumfield, 'Cakes in the Liknon. Votives from the Sanctuary of Demeter and Kore on Acrocorinth', *Hesperia*, 66 (1997), pp. 147ff.; Higgins, *Greek Terracottas*, p. 77.

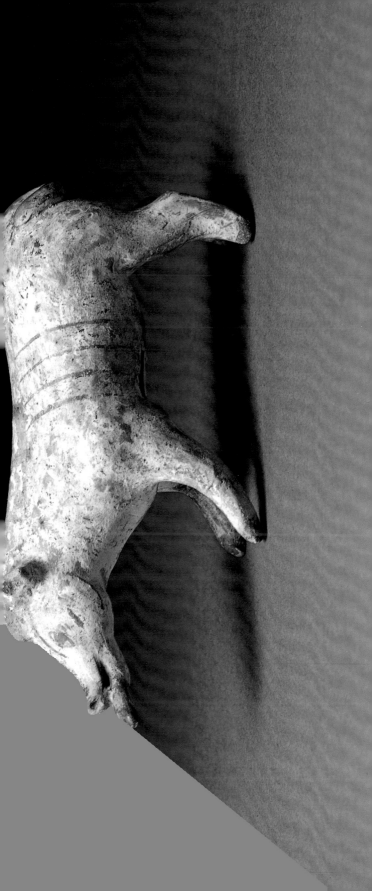

A LABOUR OF THESEUS

—

GR.22. 1937 *Red-figure neck amphora.*
Height 34 cm, width 22.4 cm. By the Pig Painter, c. 480–470 BC.
Attic production, provenance unknown. Bequeathed by
C. S. Ricketts and C. H. Shannon.

The mechanics of decorating Greek vases took a remarkable turn in the late sixth century BC with the pot painters applying black glaze for the background and using the reserve red ground from the iron-rich clay for the figures. This reversing of media is termed red-figure painting. The advantage for the artisan was that he could paint in outline, filling in the background afterwards. For a while, black- and red-figure painting co-existed, but the superior rounder results for figures in the later technique resulted in its general adoption. However, within about thirty years, artisans stopped developing ideas and began to emulate the manner of the early great innovators.

This vase is attributed to the hand of the Pig Painter, one of the anonymous 'mannerist' red-figure painters and a follower of Myson, who owes his name to another vase in the Fitzwilliam showing Odysseus (?) and a pig. The subject here is the hero Theseus performing one of his twelve labours, in like manner to Herakles (nos. 42, 49), and about to kill the Attic villain, Procrustes, who attacked travellers. Procrustes forced strangers to lie down on a bed and then would either hammer his victims to lengthen them or chop their extremities, to make them fit the bed. The drama of his own punishment is heightened in this somewhat hasty drawing by the fact that the deed is not quite done. The axe-wielding Theseus has wounded Procrustes who struggles to protect himself with an inoffensive-looking hammer. Theseus was also a king, credited with creating a union of Attic communities under the leadership of Athens. The unseen B-side of the amphora shows the amorous advance of the dawn deity, Eos, upon the handsome youth, Tithonos, whom she later arranged to have immortalised. However, having forgotten to seek eternal youth for him, she eventually shut the chattering old man up in a bed-chamber.

Further reading CVA II:2, pls. 10, 2, and 17, 9–10; ARV² I, 565, 36 (31); J. Boardman, *Attic Red-figure Vases*, no. 319; *Beazley Addenda*, p. 260; Robertson, *Vase-painting*, pp. 127, 143, 147ff.

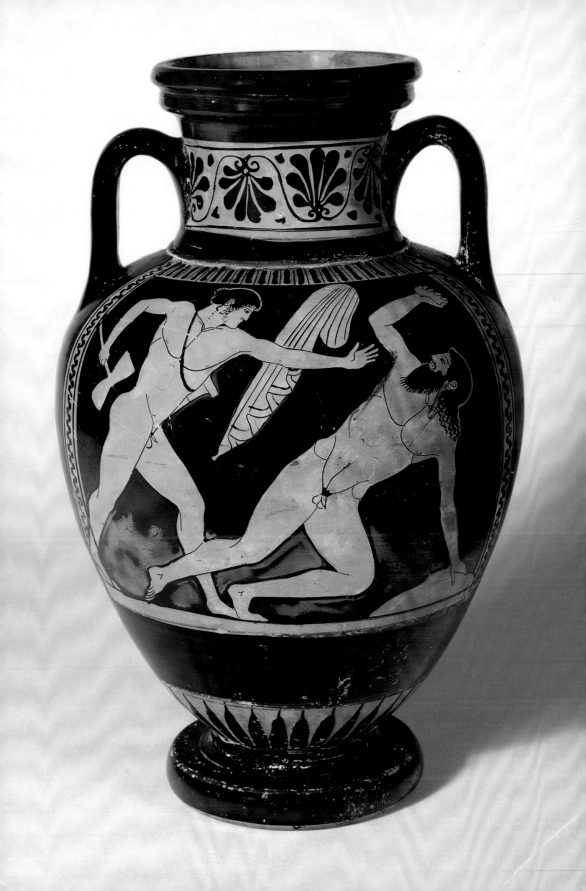

THE GODDESS PERSEPHONE(?)

GR.74.1937 *Terracotta with traces of white ground, red and blue pigment.*
Height 28 cm. 480–470 BC. Ionian manufacture (?), provenance unknown.
Bequeathed by C. S. Ricketts and C. H. Shannon.

As we have seen repeatedly (nos. 2, 8, 12, 21), it is not always clear, in these cases with female figures, whether we have before us an image of a divinity, her mortal priestess, or a votary. Archaeological context is often no more illuminating. In this quiet terracotta figure, a young maiden stands on a stepped base and somewhat coyly pulls the edge of her crinkled chiton-dress to the side, allowing the left leg to be modelled independently of the drapery. In her right hand is a pomegranate which alludes to the story of Persephone, daughter of Demeter (no. 46). Abducted in myth by Hades to the Underworld, a return to her mother was agreed, but on the way Persephone was urged to eat a pomegranate, thereby insuring her annual half-year autumn return to Hades. The pomegranate was the ultimate seed pod and favourite jewellery pendant motif, worn on necklaces by women (no. 9). However, Persephone herself embodied the essence of the bread-corn, and her disappearance from earth coincided with the scorching Greek summer. A virgin maiden, Persephone symbolised a promise of fertility.

The maiden figure was hollow-moulded in a deep front mould, and closed by hand with a plain back, cleverly made to look like a long mantle coming down from the back of the head. Her hair is centrally parted and waved, almost in imitation of the crinkly and clingy dress. Her quiet pose with slightly advanced left leg, and the gesture with her dress, were derived from the kore-figures of the last quarter of the sixth century BC. The pull to the side of the dress was a sculptural device which allowed a break in the somewhat monotonous fluting of the skirt. This feminine pose endured well into the fourth century BC (no. 30).

Further reading Higgins, *Greek Terracottas*, pp. 61ff.

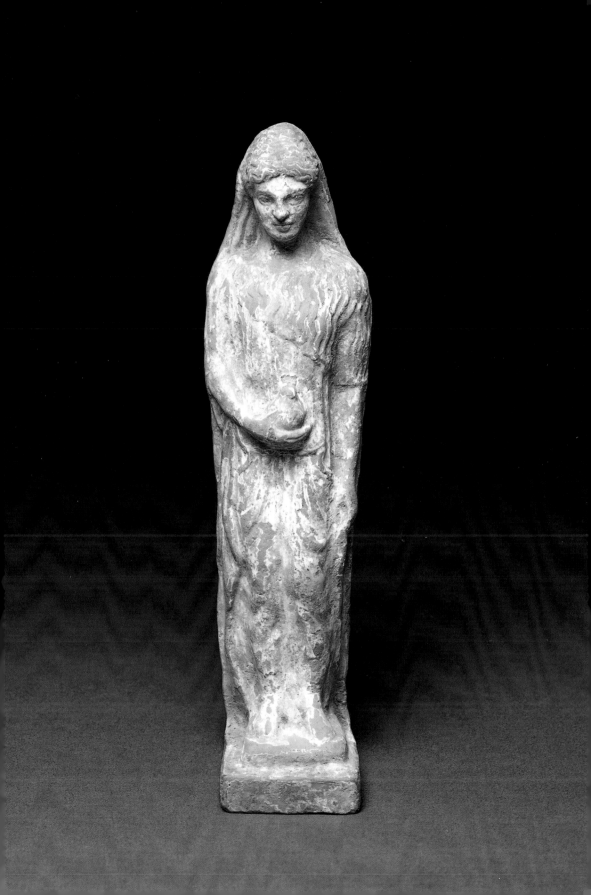

A DIVINE ASSEMBLY

*

GP.13 *Red-figure cylindroid stand. Height 29.5 cm, diameter 23 cm.*
By the Villa Giulia Painter, c. 460–450 BC. Attic production, from Naukratis, Egypt.
Given by the Egypt Exploration Fund.

Occasionally, as here, a fragmentary object of beauty is more compelling than a fine complete object. In the study of Greek vase painting, a fragment is also all that is needed to make an attribution to a vase painter. This pottery cylinder, excavated in Egypt in 1899, was made as a vase stand by the Villa Giulia Painter, who was named from another fragmentary vessel in that collection in Rome. The subject is a continuous one showing a quiet assembly of gods. The figures, identifiable by their attributes, are: Apollo, the ideal and civilised youth associated with moral and religious laws, prophecy and music, whence his *kithara* and its checked covering; a youth, possibly Ganymede, once seized by Zeus in the guise of an eagle; Artemis (no. 30), sister of Apollo with her bow and arrow (not shown); followed by Hermes, the roadside and messenger deity with his *kerykeion*-herald's-staff (no. 52); Dionysos (nos. 34, 56); and Leto (?), mother of Apollo and Artemis.

The figures stand motionless and seemingly unconnected, like a group of statues. Their poses are varied, with fully frontal and profile views, complete with foreshortened feet and with an uneven weight distribution, exemplifying a development in Greek two-dimensional representations. The linear detail is faultless, with an effort made to distinguish between the differing weights and the fall of the garments. The youth is shown, frontally, and, characteristically for the painter, with frontal feet. Apollo and Artemis each hold a shallow *phiale*-libation vessel, which is carefully drawn after actual metal examples showing two bands of repoussé decorated radiating petals. Such vessels originated in stone and precious metal at the beginning of the fifth century BC under Persian rule and were disseminated throughout the ancient world. Likewise, Attic Greek pots made their way via trading routes to the farthest reaches of the Mediterranean.

Further reading CVA 6:1, pl. 38; J. D. Beazley, 'The Master of the Villa Giulia calyx-krater', RM, 27 (1912), 286–97, esp. 289, figs. 3–5; ARV² I, 623, 73 (65); Robertson, *Vase-painting*, pp. 169–173.

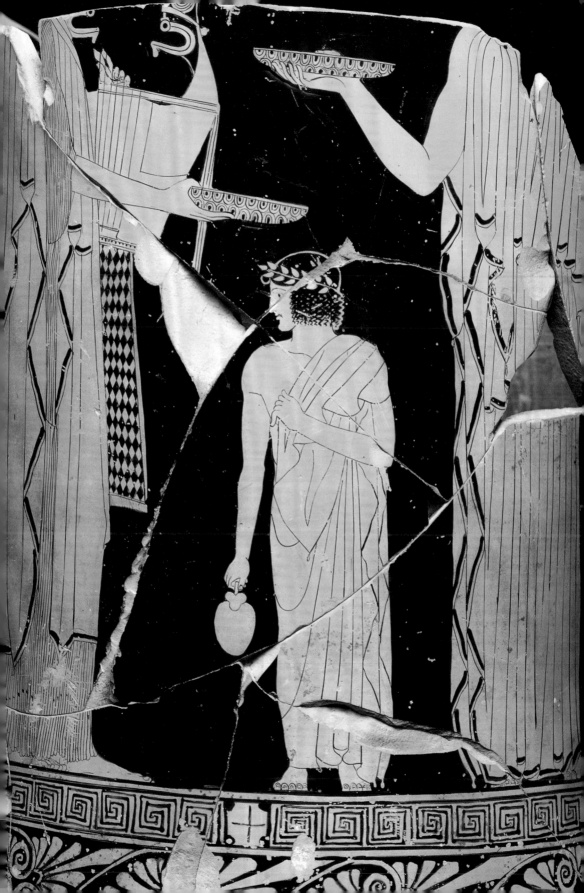

DEXAMENOS' GEM

⬤

B 34 (CM) Sapphirine chalcedony intaglio on scaraboid.
Height 22 mm, width 17 mm, depth 8 mm. C. 440 BC.
Provenance unknown. Formerly Leake Collection.

A total of four gems signed by Dexamenos have come down to us: two from south Russia, and one from Athens, with no record of where the present one was found. Born on the island of Chios, Dexamenos probably worked in Athens and enjoyed some renown at about the time the Parthenon was being built in the mid fifth century BC. Apart from images of herons, he engraved a male bust which, due to its realism, is thought to be the earliest portrait of a sitter, but which was further developed in other gems as a realistic type. Ancient artists, apart from the occasional potter or vase painter, did not usually sign their works. It is not clear whether Dexamenos signed some or all of his gems, but scholars have plausibly attributed some unsigned gems to him.

In a scene reminiscent of funerary relief stelae, a lady identified as 'Mike' or 'little one', seated on a *diphros*-chair, is confronted by her young maid who holds up a mirror and a lowered wreath. Although the relative weights of the diaphanous under-*chiton* and heavier *himation*-mantle are admirably indicated, Mike's hips are shown implausibly much narrower than the breadth of her shoulders, and the perspective of the chair legs is somewhat clumsy. In addition, the young maid stands uncertainly along the curved contour of the gem, interrupting the crenellated border pattern. Dexamenos' preference was for single subjects and a lack of ease with figural compositions may be the reason for the deficiencies in the composition. Nevertheless, the gem is greatly admired, precisely for its complex composition in this small format, especially at a time when images of women were uncommon on gems.

Further reading Henig, *Classical Gems*, cat. no. 53; Boardman, *Greek Gems*, pp. 194ff.; P. Zazoff, *Die antiken Gemmen* (Munich, 1983), pp. 132ff.

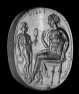

[actual size]

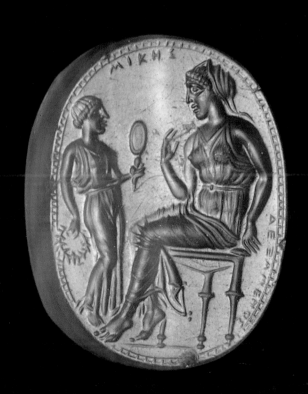

HEAD OF AN ATHLETE

—

GR.3.1948 Marble, tip of nose restored. Height 22 cm,
width 19.7 cm, depth 22.5 cm. C. second century AD Roman copy
of a fifth century BC original (of about 430 BC). Formerly Van Branteghem
and Sir Edgar Vincent Collections. Given by Viscountess d'Abernon.

Like our greatest contemporary athletes, classical athletes were revered. More importantly, representations both specific and generic were set up in public places and at sacred sites. Many of the great advances in sculptural naturalism, technique and bronze casting technology are first evident in sculptures of athletes. This head is one of a number of Roman copies, one of which is an almost-complete statue of an adolescent naked youth in a *contrapposto* pose known as the Westmacott Athlete (after a collector), in the British Museum. It is thought to be derived from a bronze sculpture of an actual boxer named Kyhiskos, by Polykleitos, the master sculptor who developed a canon of figural ratios along with a pose of rest and effort (no. 37). The boxer was either placing a victory wreath on, or removing one from, his head. The style of the sculpture dates to about 430 BC, whereas the inscribed plinth of the boxer found at Olympia is thought to be earlier. While the Westmacott Athlete, and therefore this head, may not copy the boxer of Polykleitos, both are most certainly Polykleitan in inspiration and may be the work of a follower.

The youth is shown in an idealising way with head lowered to the right, impassive face and otherworldly gaze. His hair is like that on other Polykleitan heads but more complicated. His ears are thickly carved but not the swollen ears that identify boxers in a later period. Likewise his nose is classically straight and not shown broken. The Romans collected Greek sculptures avidly, and manufactured copies by means of plaster casts or by a mechanical pointing system for both public and private settings.

Further reading Budde and Nicholls, *Catalogue*, cat. no. 42; Frankfurt, *Polyklet*, esp. pp. 585ff.; B. S. Ridgway, in W. G. Moon, ed., *Polykleitos, the Doryphoros and Tradition* (Madison, 1995), pp. 177ff.

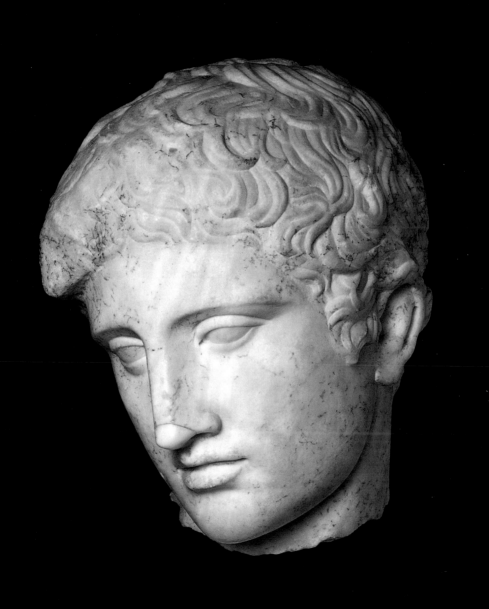

THE GOD ASKLEPIOS

—

GR.98.1937 *Marble (Pentelic).*
Height 48.2 cm, width 25.6 cm. Attic production, provenance unknown.
Fourth century BC. *Bequeathed by C. S. Ricketts and C. H. Shannon.*

In the Christian period, a person of means might dedicate an altarpiece or picture of the Holy Family showing himself and relatives within the same panel or canvas. So too, in earlier antiquity, families dedicated votive relief panels showing themselves before their favoured gods at their shrines. This was particularly the case in the fourth century BC. The usual format was rectangular, with an architectural frame of *antae* at either side and roofline punctuated by *akroteria* along the top. Within, the divine recipient was shown on a large scale, often attended by his or her divine consort, with groups of votaries on a smaller scale, sometimes with children in tow, crowding before them. The deities could be enthroned or standing more informally and leaning on a staff or tree, and sometimes cavalierly overlapping the architectural frame.

Here we see the healing god, Asklepios, recognisable from his staff with the snake coiled around it. His cult appealed to the common man because it enabled a direct personal relationship with the deity. His larger temples were equipped with places for incubation for health cures, with amenities such as gymnasia and baths, as in modern-day sanatoria. Asklepios was always shown as a mature, bearded man with a mild expression. In this large compelling fragment, he appears in three-quarter view of increasing depth towards the near shoulder, wearing a heavy woollen *himation*-mantle, the draping of which summons up the idea of the rich crinkles and folds of modern taffeta. He leans on his staff and presumably towards the approaching faithful, but the traces of his head, no longer extant, betray his outward-facing otherworldliness. The hand on his right shoulder is that of his daughter, Hygeia, who personified good health and from whose name our word 'hygiene' is derived.

Further reading Budde and Nicholls, *Catalogue*, cat. no. 34; U. Hausmann, *Griechische Weihreliefs* (Berlin, 1960), pp. 69ff.; Robertson, *History*, pp. 373ff.; Boardman, *Greek Sculpture*, ch. 7.

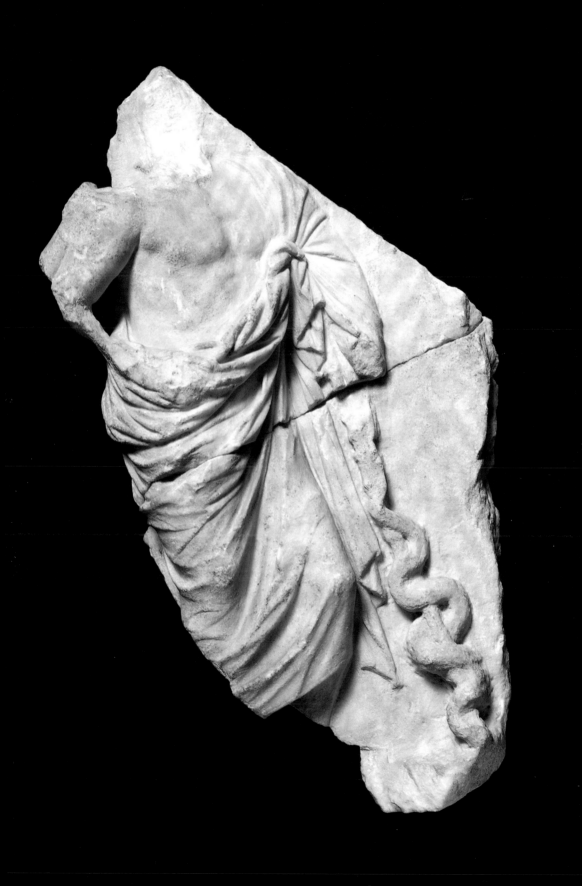

ARTEMIS WITH HIND

—

GR.7.1977 *Terracotta. Height 39.3 cm,*
width 11.8 cm, depth 8.9 cm. C. 450–440 BC.
Cypriot manufacture, provenance unknown.
Bequeathed by Mr and Mrs H. W. Law.

As a deity of uncultivated hills and forests, Artemis was both goddess of animals and a huntress. Although a maiden, she was credited with powers of fertility over beast and man, and was considered an aid to women in child-birth. In this large terracotta statuette, Artemis wears a high *polos*-headdress, *chiton* and *himation* under- and overgarments, and is bejewelled with large rosette-and-drop earrings, a beaded necklet, a richer necklace with pendant drops, and bangles on both wrists. The jewellery conforms to well-known contemporary types found throughout Greece and south Italy. It is perhaps strange to us that this nature goddess should be so beautifully turned out, wearing many jewels with only a doe as a prop, but it is this and a small bird which is all that was necessary to evoke the idea of Artemis. Nevertheless, we cannot be sure that the image is not that of a maiden priestess in the cult rather than the goddess herself.

Because of her broad powers and qualities, Artemis was easily assimilated with foreign goddesses of similar type. A number of related decorative terra-cotta statuettes from Salamis, Cyprus, show the maiden either with a bird, flower, or fruit, or with a lyre. The drapery and the bird offering certainly recall the images of the Ionian maidens who influenced this Cypriot votive mould-made statuette type, produced in the middle of the fifth century BC.

Further reading T. Monloup, *Les terres cuites classiques: un sanctuaire de la Grande Déese = Salamine de Chypre 14* (Paris, 1994), pp. 9ff, 23ff, 69ff.

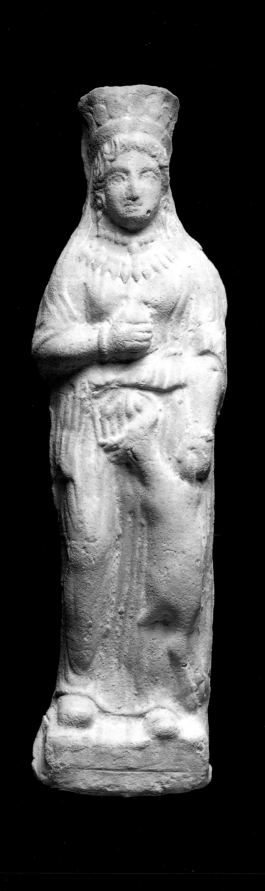

FUNERARY STELE

—

GR.6.1890 Marble (Pentelic) with traces of red
pigment on face. Height 88.5 cm, width 85.5 cm. C. 350–325 BC.
From Marion, Cyprus. Given by the Cyprus Exploration Fund.

Since time immemorial, man has sought to mark the final resting place of his fellow humans. Indeed, so common was this practice that classical Athens twice saw fit to pass sumptuary laws to forbid *stele*-grave-markers. The first decree (*c.* 500–480 BC) was probably overturned after the start of the Peloponnesian war (*c.* 430 BC), stirred by the additional crisis of the plague. The second anti-luxury decree came into force in 317 BC, causing Athenian sculptors to join the Greek diaspora elsewhere.

A *naiskos*-stele tends to show the deceased sitting or standing within an architectural setting framed by vertical *antae*, an architrave often inscribed with the name, and a pediment crowned centrally and laterally by *akroteria*. In this instance the dead man projects from and overlaps this framing device. He is shaggy-haired and bearded, with his head turned and lowered and fixed with an otherworldly gaze, in a style applied to images of philosophers and the dead. That he wears an eastern sleeved-*chiton*, while heavily swathed in a deeply carved woollen *himation*-mantle, suggests he is a non-Athenian or one at least who adopted eastern ways. Of Athenian marble and workmanship, but found in Marion, Cyprus, and probably dating to just before 317 BC, this stele raises the question of whether it was commissioned in Athens, the figure having been selected from a pattern book, albeit with modified dress, or whether the sculptor was an itinerant one working in Cyprus. Native tomb markers, often depicting the sphinx, appear sometime in the sixth century BC, but the fifth century BC Cypriot monuments tended to follow Greek ones more closely. After the second sumptuary decree, many Athenian sculptors probably continued working in Cyprus.

Further reading Budde and Nicholls, *Catalogue*, cat. no. 31; C. W. Clairmont, *Classical Attic Tombstones* I (Kilchberg, 1993), cat. no. 457; V. Tatton-Brown, in V. Karageorghis, ed., *Cyprus Between the Orient and the Occident* (Nicosia, 1986), pp. 439–453, esp. 449ff.; Robertson, *History*, pp. 363ff.; Boardman, *Greek Sculpture*, ch. 6.

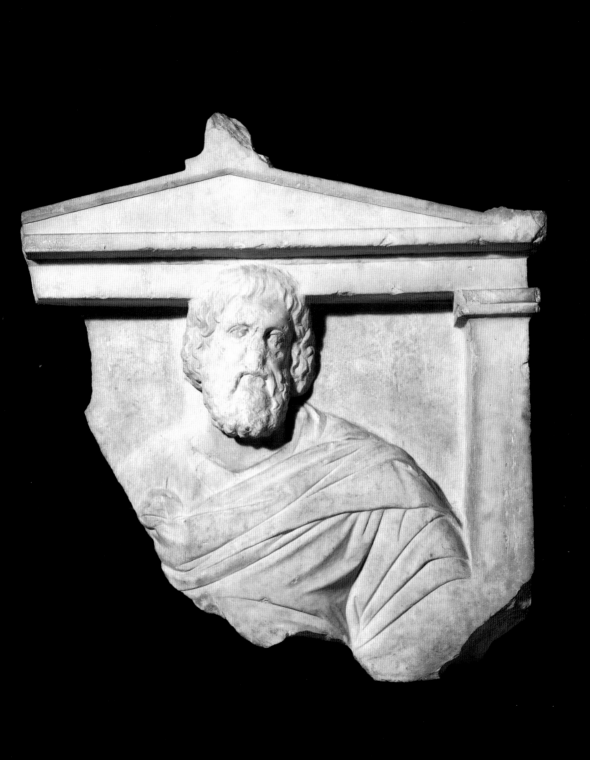

CROCODILE ATTACKING
A NEGRO

◦

GR.58.1865 *Red-figure ware.*
Height 22.2 cm, width 16 cm, diameter 10 cm. Negro group
workshop after Sotades, c. 350 BC. Apulian manufacture, provenance unknown.
Formerly in the 4th Earl Cadogan Collection.

The crocodile was both a feared and revered beast on the River Nile. It was known to menace fishermen and farmers, attacking animals and men. The crocodile was also reviled as a reptile of the Underworld. The Nubian black was one of the traditional enemies of Egypt to be vanquished or subdued by the pharaoh. These southerners were said by the Egyptians to eat crocodiles. However, it was not an Egyptian idea to show the crocodile attacking a negro, but a Greek one, a notion possibly derived from violent Phoenician images. Greeks had encountered Nubians, possibly in the Persian armies, certainly through descriptions from Greeks settled in Egypt, and later in Greece and southern Italy. The Greek historian Herodotus (II, 69) related how the Egyptians adorned crocodiles, made them food offerings, and embalmed them after death. No doubt the Greeks associated both crocodile and black men with Egypt.

The horn-shaped rhyton-vessel was ultimately derived from Persian examples in precious metal. This red-figured ceramic type was made in a piece mould with a wheel-thrown upper section. The crocodile appears in the reserve red ground and the negro appropriately in black glaze. Satyrs were often likened to negroes on Greek vases, but the one which appears here below the lip is clearly Caucasian and in the reserve red. The prototype vessels were first made in the Attic workshop of a man named Sotades around 470 BC. The vessels were exported to Italy where the shape and composition were later imitated in Apulia by immigrant Greek artisans and potters.

Further reading E. Buschor, 'Das Krokodil des Sotades', MüJb I/II (1919), pp. 1–43; A. D. Trendall and A. Cambitoglou, *Red-figured Vases of Apulia* II (Oxford, 1982), ch. 21, pp. 613ff.; J. Vercoutter *et al.*, *The Image of the Black in Western Art* I (Lausanne, 1976), pp. 150–160, 174–175, 272–273; Robertson, *Vase-painting*, pp. 185–190; H Hoffmann, *Sotades: Symbols of Immortality on Greek Vases* (Oxford, 1997), ch. 1.

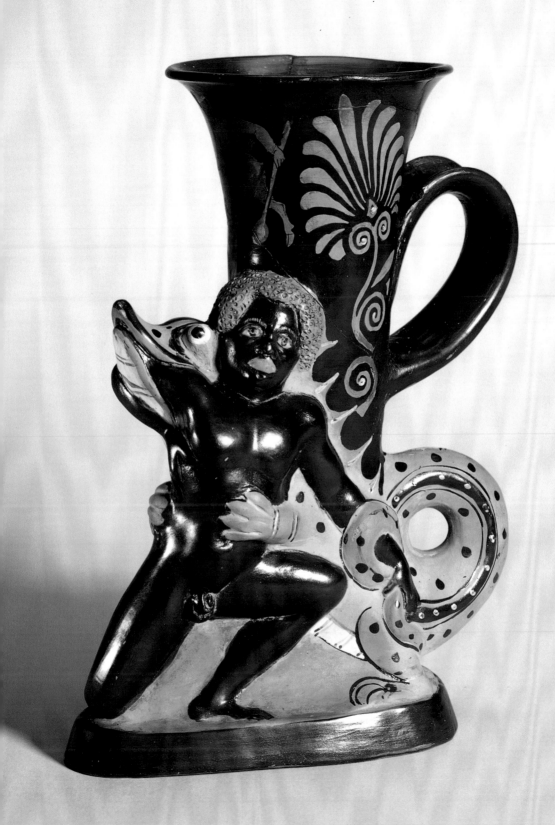

ALEXANDER THE GREAT

—

GR.69.1970 Marble. Height 59 cm. C. 100 BC. Said to come from
Ptolemais Hermiou, Egypt. Purchased through the Greg Fund.

As Alexander the Great went east to hellenise 'barbarian' horizons, he secured
and garrisoned each new land he conquered. Having 'liberated' Egypt from
the Persian yoke, he was crowned pharaoh at the native temple of Amun at
Siwa in 331 BC, where he was 'informed by the god' that he would be an invin-
cible ruler. Before continuing on his military campaigns, he founded the city
of Alexandria. When he died eight years later, his general Ptolemy, acting as
satrap in Egypt, kidnapped Alexander's funerary cortège and eventually trans-
ferred the Egyptian capital, the coin mint, and the preserved body of Alexander
to Alexandria (c. 313 BC). King Ptolemy 'the Saviour' enjoyed legitimacy and
divine protection through the presence of the divinised Alexander whose
embalmed body could be visited and viewed.

A number of statues of Alexander the Great were created to perpetuate his
cult, with a repertoire of elements such as youthfulness, beardlessness with
thick hair in disarray and stubbornly up in an *anastole* at the brow, and often
with the diadem of Dionysos, who in myth conquered the east (no. 56).
Alexander is also characteristically shown with a contemplative gaze symbol-
ising his philanthropy towards his subjects, and sometimes facing upwards,
emphasising his divine kinship. The cult statue associated with Alexander's
corpse was probably the Aegiochos type shown here. Alexander wears a
symbol of Zeus and Athena: a large *aegis*-goatskin bordered with snakes and
decorated with a Gorgon head (no. 20). His right arm was raised to grasp a
sceptre or spear, and in his left he held a statuette copy of the famous Athena
Palladion-warrior. The sculpture thus encapsulated a number of meanings.
The *aegis*, sign of protection, and worn as a *chlamys*-tunic, recalled the shape of
the city of Alexandria. Together with the image of Athena it put the city of
Alexandria, now ruled by Ptolemy, Alexander's legitimate successor, firmly
under the protection of the goddess. The statue, copied for centuries, was
seemingly a popular military dedication which also enhanced the name of
Alexander as 'Alex-andros', the repeller of men.

Further reading Stewart, *Faces of Power*, pp. 250ff., pp. 421–422; Smith, *Royal Portraits*,
pp. 34ff., 47ff.

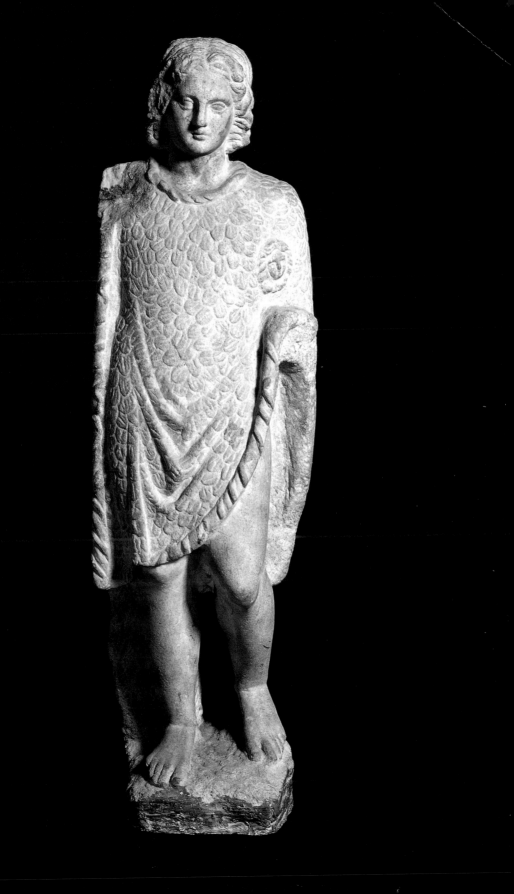

BUST OF DIONYSOS

—

GR.119.1937 *Copper alloy with silvered eyes.*
Height 11.1 cm, diameter 7.6 cm, depth 4.1 cm.
Late second–first century BC. *Provenance unknown.*
Bequeathed by L. D. Cunliffe.

Due to his identification with Alexander the Great, the image of Dionysos, who supposedly like his mortal equivalent once conquered the east (no. 56), became a popular fixture on furnishings in the Hellenistic Period. His bust and those of his entourage of maenads and satyrs regularly adorned metal vessels and especially the sides of the inverted s-shaped *fulcrum*-bed-ends (no. 43). It was, no doubt, the god's surrender to wine and its effects, and the belief by some that he slept in winter and was awake in summer, that made these heads an especially appropriate choice for boudoir decoration.

The god is depicted as a youth with his head sharply turned to his left side and upwards as if in ecstatic abandon, but also facing the lost finial of the *fulcrum*. In contrast, his hair is neatly combed and ordered, and decorated with a fine wreath of ivy with corymbs. Two cork-screw tresses rest on each shoulder among the somewhat carelessly arranged clinging *chiton*-tunic and diagonally draped fawn skin with the ends of a mantle swept up over his left shoulder. The whites of the god's eyes were silvered and the pupils were once inlaid in a contrasting material. A sunken band across the forehead for a fillet, and one vertically along the tunic, were probably also inlaid with a contrasting and presumably precious metal. Together with the superb hollow casting with openwork wreath, these features indicate an excellent level of craftsmanship for what was essentially a common decorative element. Indeed, a bust with almost the identical drapery treatment in Kassel, but with a different head, demonstrates how such ornament moulds could be both repeated and varied. The figure was originally mechanically attached by means of nails through four perforations on the bust.

Further reading B. Barr-Sharrar, *The Hellenistic and Early Imperial Decorative Bust* (Mainz, 1987), p. 54; M. Bieber, *Die antiken Skulpturen und Bronzen des königlichen Museum Fridericianum in Kassel* (Marburg, 1915), pl. 48 no. 299; Faust, *Fulcra*, cat. no. 87.

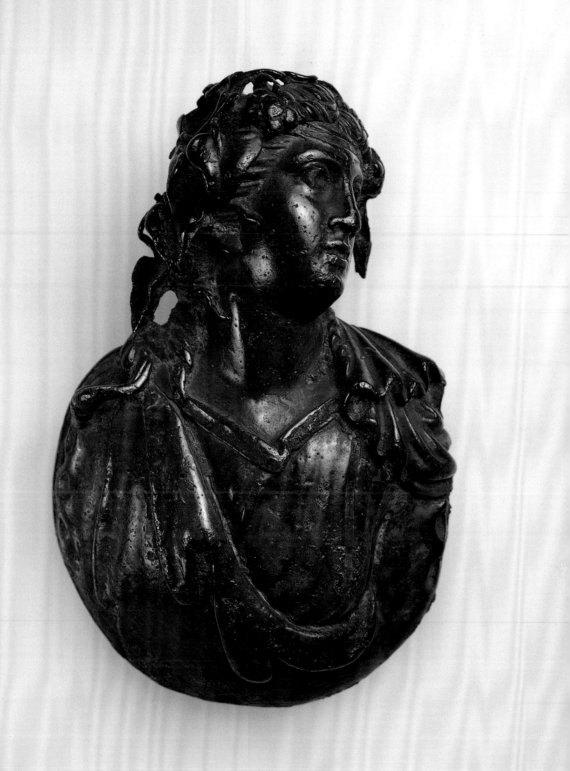

APHRODITE ANADYOMENE

—

MARBLE

GR.3.1954 Height 24 cm. GR.2.1954
Height 22 cm. C. second century BC. From Egypt.
Bequeathed by Sir Robert Greg.

The painter Apelles was an admirer of the female form, and was particularly taken with the mistresses of both Alexander the Great (no. 33) and the sculptor Praxiteles, both of whom modelled for him. He was so besotted with the former that Alexander the Great gave her as a gift to the painter. Apelles owed his centuries of fame to his mural painting on the island of Kos of the goddess Aphrodite, naked as she emerged from the sea wringing out her hair or *anadyomene*. This was probably a life painting of Praxiteles' mistress, and it attracted visitors and connoisseurs for centuries. Indeed, the painting invited such interest that the subject was adapted in sculpture, both naked and semi-draped. Both versions were widely copied, and the naked version was especially popular in Egypt, perhaps aided by the deification of Queen Arsinoe II (270 BC), who was assimilated with Aphrodite, a ruler deification trend facilitated by that of Alexander the Great. The *anadyomene* subject was also disseminated on east Greek coinage.

The naked goddess of love is shown here in two near-contemporary statuettes from Egypt, with her weight on the left leg, which, together with the sideways tilt of the upper torso and the raised right arm, results in a chiasm of the body so that the left hip is higher than the right, whereas the height of the shoulders is reversed. Her arms were once positioned to wring out the long wet tresses in a pose which suggested both rest and activity. Had the figures been cast in bronze, the addition of a strut, evident on the left leg, would not have been necessary. Marble sculptures and statuettes require this feature.

Further reading D. M. Brinkerhoff, *Hellenistic Statues of Aphrodite: Studies in the History of their Stylistic Development* (New York and London, 1978), ch. 3; J. W. Salomonson, 'Furtwänglers "Anadyomene"', *BABesch*, 70 (1995), pp. 1ff. C. M. Havelock, *The Aphrodite of Knidos and Her Successors: A Historical Review of the Female Nude in Greek Art* (Ann Arbor, 1995), pp. 86ff.

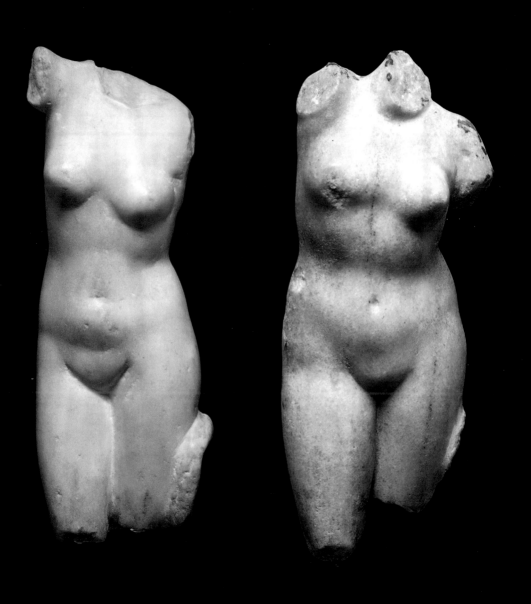

DRUNKEN HERAKLES

—

GR.5.1977 *Bronze with tin-lead surface. Height 24.4 cm.*
Provenance unknown. GR.1.1864 *Bronze. Height 22.5 cm. Acquired from*
Agrinion Akarnania in Aitolia. Formerly W. M. Leake Collection.
Hellenistic Period, third–first century BC.

The hero Herakles was not only shown at his labours (nos. 41, 49) but also at rest like a man (no. 38) and in the company of gods, demonstrating his divinity. On Greek vases he appears at a dinner party (symposium) with Dionysos, god of wine, or staggering home afterwards wearing a circlet or branches in his hair as an allusion to the divine symposium. It is possible that these scenes and many others showing Herakles drunk refer to a lost comic play in which satyrs steal the hero's weapon, clothes and accoutrements while he is under the influence of wine.

In these remarkably similar hollow-cast bronzes, one of which preserves the attributes, we see the bearded and muscular Herakles progressing in an unstable way with club swung back over his left shoulder as he looks down at a drinking vessel brimming with fruit. It has been suggested that these figures literally represent the hero's drunken return from the symposium and descent from the mountain, decorating the shoulders of monumental wine vessels. As we have seen, cast figures not uncommonly adorned hammered vessels (nos. 17, 19).

The figures were cast in piece moulds with limbs joined roughly at the same points, and both had a rectangular open section in the same position on the upper back, which was successfully plugged in one case. However, the figures do not come from the same mould, as is evident from the variations in leg positions, differences in muscular definition, and the deviation in headgear. Related figures survive in other collections suggesting this was a popular subject. The more fully preserved figure here was also surface-coated with a tin-lead alloy for a more precious silver effect.

Further reading R. V. Nicholls, 'The Drunken Herakles. A New Angle on an Unstable Subject', *Hesperia*, 51 (1982), 321–328; *LIMC* v, 3270; Vollkommer, *Herakles*, pp. 51–52, 67ff. D. Noel, 'Du vin pour Héraklès', in F. Lissarague / F. Thelamon, eds., *Image et céramique grecque. Actes du Colloque de Rouen, 25–26 novembre 1982* (Rouen, 1983), pp. 141–150.

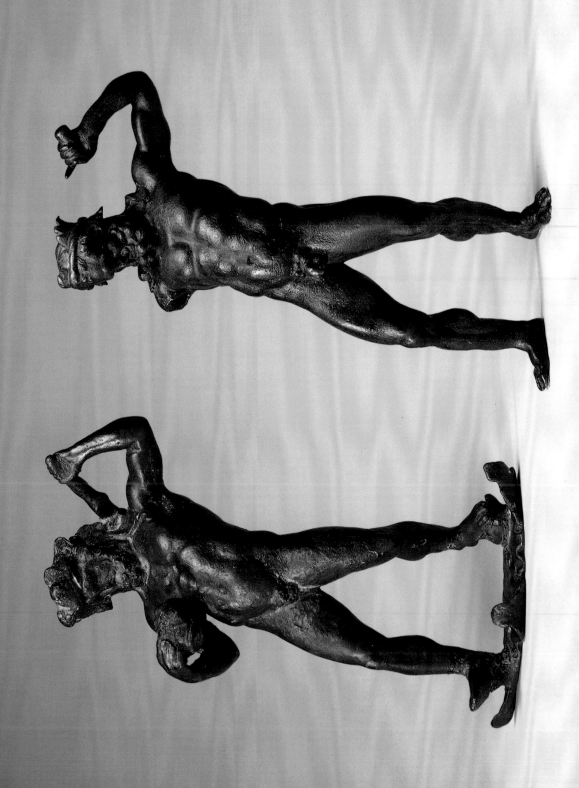

TORSO OF AN ATHLETE

—

GR.T.27 *Terracotta with traces of pigment.*
Height 8.1 cm, width 4.1 cm, depth 2.4 cm. C. second–first century BC.
Provenance unknown, possibly Turkey (?).

Male nudity in ancient Greek images signified gods, idealised youth, or athletes who usually competed nude. Although fragmentary, there is much we can read from this torso. The figure is that of a young athlete, possibly derived from a bronze sculpture by Polykleitos of an actual boxer named Kyniskos crowning himself with the wreath of victory. The famous sculpture, set up within the sacred precinct of Olympia, was described by the ancient travel writer Pausanias, and it is thought that it is preserved in a copy called the Westmacott Athlete at the British Museum (no. 28). Although highly valued and widely copied, few large bronze sculptures of the classical period survive – they were often melted for re-use.

In this miniature terracotta copy the youth stands with weighted left leg, advanced and weightless right leg, lowered left arm and raised right: a visual chiasm of the limbs, known as a *contrapposto*-pose. A similar combined pose of rest and effort (reversed) was developed by Polykleitos in a statue of an athlete bearing a spear (*doryphoros*), about which he also wrote a treatise, now lost.

A number of terracotta youthful athletes modelled after famous classical prototypes were made in Greek Asia Minor during the Hellenistic Period (third–first century BC). The body definition and the amount of movement in this stationary pose, that is, the swing of the hip and angle of the shoulder relative to the stationary limbs, varies from figure to figure. Here our youth is static and highly idealised to the extent that the reverse is unremarkable for its pose, though not for its definition. Such images were moulded in the same spirit as the 'Tanagra' figurines (no. 39), and all such figurines were collected avidly in the late nineteenth century.

Further reading Frankfurt, *Polyklet*, pp. 585ff.; E. Bartman, *Ancient Sculptural Copies in Miniature = Columbia Studies in the Classical Tradition* (Leiden, New York, Cologne, 1992), pp. 20–22.

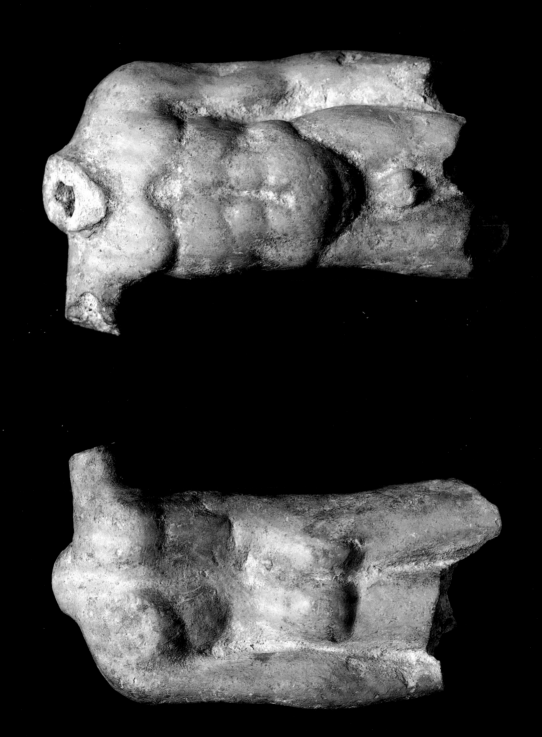

A PHILOSOPHICAL
HERAKLES

—

GR.88a.1937 *Terracotta.*
Height 7.0 cm, width 5.5 cm, depth 3.5 cm.
Second century BC, from Turkey. Bequeathed by
C. S. Ricketts and C. H. Shannon.

Although Herakles is the quintessential example of the ancient action man (nos. 41, 49), who performed twelve labours and many other toils, he was also praised as humane and virtuous. In the fifth century BC, sophistic, cynic and stoic philosophers noted that Herakles had accepted his burden and executed these labours, achieving eternal life. Thus he could be shown in a reflective state, having shed his knobbed club weapon and having exchanged his fierce lion skin for the garb of a philosopher. Indeed the sophist Herodoros stated that he overcame 'desire by means of the club of philosophy, having exchanged the lion skin for virtuous reason . . . living like a philosopher until his death'.

The most famous statues of Herakles in repose depict him leaning on his club sheathed by his redundant lion skin (Farnese *Herakles* now in Naples) or sitting on a basket, both attributed to the famed sculptor Lysippos. The present example shows an older contemplative Herakles with head downcast, unarmed, with his right arm completely enveloped by his *himation*-mantle, no doubt in a *contrapposto*-pose (with weighted right leg; advanced and weightless left leg). The type is based on classical sculptures of philosophers of some two centuries earlier (classicistic style), but produced in Greek Asia Minor during the Hellenistic Period.

Further reading Vollkommer, *Herakles,* pp. 79ff.

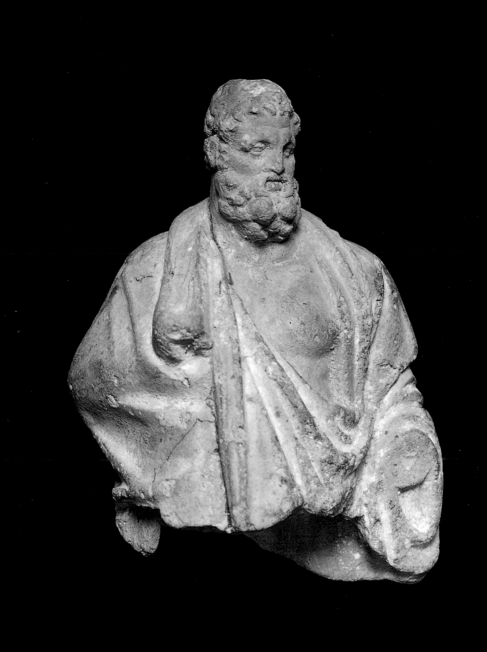

'TANAGRA' FIGURINES

—

TERRACOTTA

GR.86.1984 *Youth seated on rocks. Height 17.2 cm.* GR.62.1937
Standing woman with wreath. Height 24 cm. GR.86a.1937 *Seated girl.*
Height 8.5 cm. Attic. GR.86b.1937 *Standing boy. Height 12 cm.* GR.68.1937
Standing woman. Height 23 cm. Asia Minor. GR.77.1984 *Standing girl. Height 15.6 cm.*
Attic. GR.66.1937 *Standing woman. Height 25.5 cm. Asia Minor.* GR.79.1984 *Standing*
girl with hat and fan. Height 16.3 cm. GR.79.1937 *Seated youth. Height 12 cm.* GR.64.
1937 Standing woman with hat. Height 28.5 cm. GR.77.1937 *Seated girl. Height 14 cm.*
Unless specified, provenance thought to be Boeotia. 1984 numbers formerly Chesterman
Collection; 1937 numbers were bequeathed by C. S. Ricketts and C. H. Shannon.
Late fourth-second century BC.

Iconography can be defined as the examination of the image in search of its meaning as embodied in its pose, attributes, etc. It is therefore difficult to read representations of fashionably dressed ladies in coquettish poses, seated men and well-groomed children with otherworldly gazes. They are not presented as worshippers as their arms are not upraised (orants), and they do not hold significant attributes (nos. 12, 30) to equate them with deities or mythological figures.

Such terracotta figurines as these were produced in great quantities from about 330 BC at the site of Tanagra in Boeotia (and often called 'Tanagras') but their popularity and production after 200 BC continued elsewhere, as far away as Greek Asia Minor. They were largely found in tombs and therefore their meaning must have been profound. Their function was possibly to recall family members who would act as companions in the Hereafter. Nevertheless, such figurines were produced at a time when sculptors and terracotta modellers (coroplasts) were capable of great realism, and the preference for idealism in contemporary dress and the lack of the specific and the distinctive (apart from grotesque and highly deformed figures) suggest that these are generic images referring to people of different ages related to the deceased. However, their possible use also as toys during life should not be excluded.

The figures were moulded in two-part terracotta moulds (often applied to a rectangular plinth for stability), and were fired in a kiln and then painted, usually over a white undercoat. They were eagerly collected in the late nineteenth century and predictably a great number of fakes were introduced onto the market.

Further reading Higgins, *Greek Terracottas*, pp. 97ff., 101ff.; Uhlenbrock, *Coroplasts's Art*, chs. 5, 8.

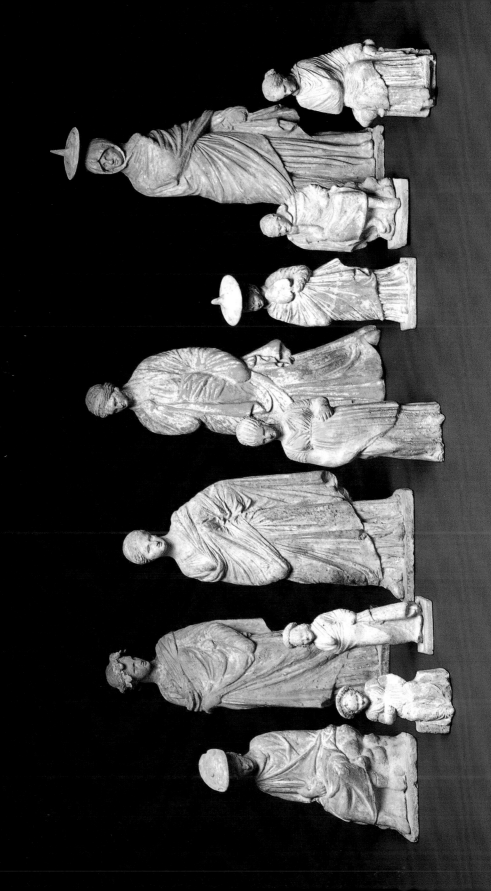

A CHILD'S HEAD

—

GR.2.1992 Marble.
Height 16.5 cm, width 13.3 cm, depth 16.5 cm. C. 330 BC.
Provenance unknown. Bequeathed by Warren Pollock.

It is difficult for us today to imagine a society in which children were not the central focus of family life. However, due to the uncertainty of survival, it is sometimes said that children in antiquity were kept at arm's length emotionally. Children were depicted on funerary monuments, but it was more usual for them to be shown almost as a prop, mourning the passing of an older heroic son or of a parent. Votive sculptures of children were not common until the fourth century BC, when they were especially sentimentally modelled in miniature terracotta form (no. 39). Because of their purity, children did play an important role in public cults, so that for example they might carry sacred ritual objects in processions. At the sanctuary of Artemis at Brauron, where a number of children's images have been found, they would dress up and dance like little bears.

This sweet marble head is that of a small girl who wears her hair combed into the central *skorpios* or *plochmos*-plait of toddlers. The plait could be dedicated to gods who were particularly concerned with the birth or welfare of children, such as Eileithyia, Artemis, Asklepios and Demeter. This head is so successful because it was modelled as a child with high rounded forehead, very full child-like cheeks, and small upturned nose, and not as an adult with only the enlargement of the cranium (no. 45). The eyes are, however, idealised and could otherwise be those of an adult image. The lips of the rosebud-shaped mouth are slightly parted, a convention of the late fourth century BC. The crown of the head is cut away and stepped on the left side and polished, a technique associated with areas poor in marble, such as Egypt and Libya, where sculptures were often built up of smaller pieces of stone.

Further reading C. Vorster, *Griechische Kinderstatuen* (Cologne, 1983), pp. 48, 85ff. cat. no. 188; H. Rühfel, *Das Kind in der griechischen Kunst* (Mainz, 1984), pp. 213ff.

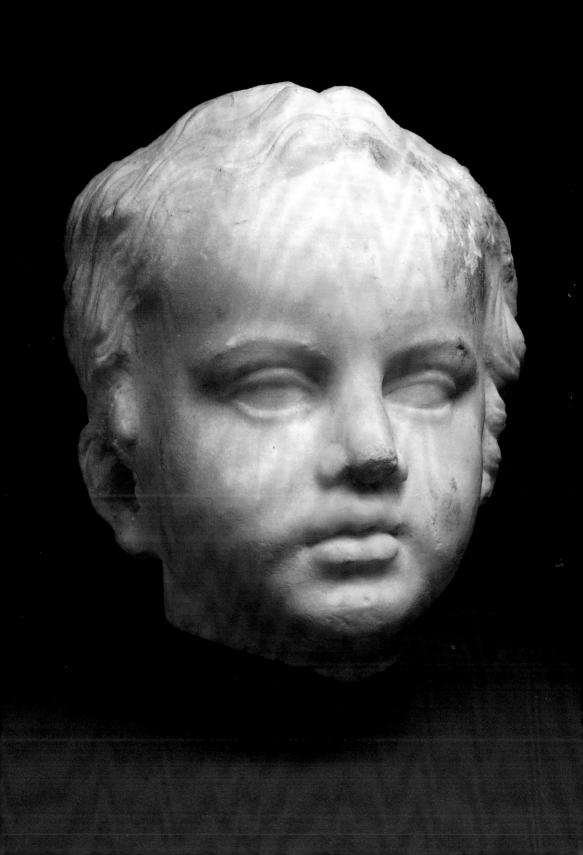

CISTA

◄

GR3.1965 Bronze cista, traces of gilding.
Height 40.6 cm, diameter 23 cm. Handle height 11.4 cm.
Formerly Spencer-Churchill Collection. Purchased through R. P. Hinks,
Victoria and Albert Museum Grant-in-Aid and National Art-Collections Funds.
GR.5.1925 Separate handle. Height 11.7 cm; width 13.8 cm,
C. third century BC. From Praeneste, Italy.

Ancient cosmetics were kept in round, lidded vessels (nos. 6, 18, 57) and, southeast of Rome in Praeneste (Palestrina), affluent people included in their tomb furnishings substantial bronze *cistae*-vessels for such necessaries. These remarkable vessels were engraved with mythological scenes. Their lids were usually made with handles composed of two figures arm in arm, or two holding the body of a dead warrior. This superb and evenly hammered vessel was finely engraved and then passed on to another craftsman so that the cast feet, handle grip and suspension loops for hanging chains (not preserved here) could be attached. The 'assembly-line' manufacture often meant that the attachments were added without regard to the underlying decoration.

The incised mythical story of the gigantomachy tells of the battle between the Olympian gods aided by Herakles, and a savage race of giant men. Here Athena prepares to spear an opponent on one side of the composition and Herakles does battle on the other, with quadriga-led Victory sweeping through the centre. Ancient Praeneste was a Latin-speaking city situated between the Greek-speaking south and the Etruscan north, and so Greek iconography was often purposefully altered. In this example, the workshop has seemingly confused subjects from different myths: e.g. a giant is depicted as a triton; a fallen giant appears in the pose of a dying Amazon; and Herakles wears a wolf-skin and not his usual lion-skin. Such details have prompted scholars to condemn wrongly some *cistae*. In this case, minute traces of gilding displaced by the underlying corrosion on both lid and body, but also largely 'cleaned' by a misguided restorer earlier this century, testify to its antiquity.

Further reading Doubted by Bordenach Battaglia, *Le ciste*, pp. 73–75; G. Foerst, *Die Gravierungen der pränestinischen Cisten* (Rome, 1978), p. 433, no. 16, pls. 12b–c, 13a–c; F. Vian, *Repertoire des gigantomachies figurées dans l'art grec et romain* (Paris, 1951), pp. 96ff.; Cleveland, *The Gods Delight*, cat. no. 45; Oddy *et al.*, in Getty, *Small Bronze Sculpture*, pp. 103ff.

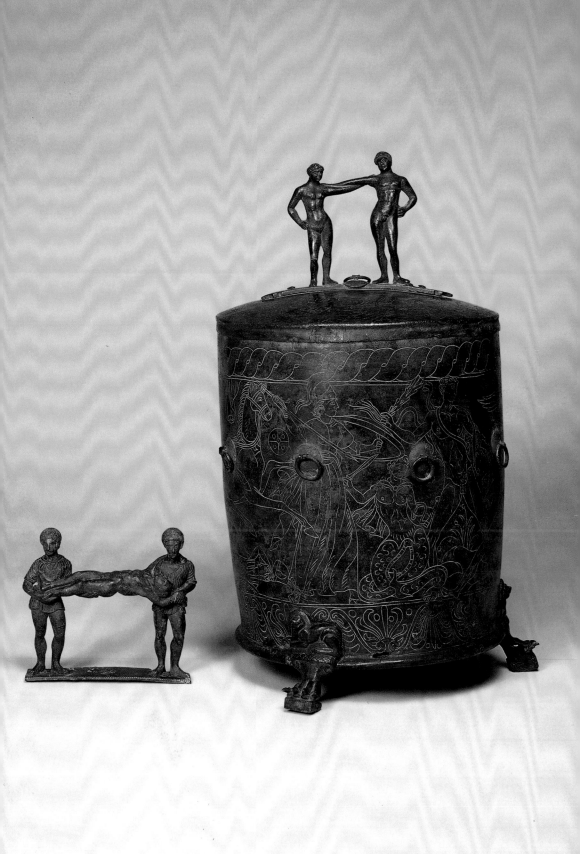

ETRUSCAN MIRROR

—

GR.10.1972 *Bronze mirror: copper 91.0%; tin 7.83%;*
bone handle. Height 30.9 cm, diameter 17.15 cm. Vulcan manufacture,
provenance unknown. Purchased through the Cunliffe and National Art-Collections
Funds. E.101.1937 Bone handle with Gorgon heads. Height 9 cm. Bequeathed
by C. S. Ricketts and C. H. Shannon. Both fourth century BC.

Great care was taken to prepare the tomb and the deceased for the Afterlife.
Grave goods included objects that were used in life, such as mirrors, but these
may have had yet another purpose: to re-vivify the image of the deceased (no.
57). In Etruria and Praeneste (no. 41) the reverse side of mirrors could be
engraved, often with mythological scenes. In a scene here from Homer's
Odyssey, the hero is about to slay the seated Circe, a goddess who transforms
men into fawning beasts. In fact Odysseus mollified Circe, later identified with
a promontory in Latium, and lived with her for a year, after which she directed
him home. In a departure from the text, the Etruscan artist has included here
the youth Elpenor, who was a minor figure in the *Odyssey*. Bone handles are
uncommonly preserved. The separate handle here has a mythical Gorgon head.
This warded off evil, which may suggest that the use of mirrors was thought to
invite the evil eye.

The earliest metal mirrors come from the Near East and Egypt (Dynasty
VI, 2289–2152 BC) and were made of unalloyed copper, which was cast in a
roughly circular, convex shape, hammered, and annealed. Mirrors appeared
in Greek lands by around 1500 BC, by which time tin had been added to solve
porosity problems and thus allowed a more even and reflective surface.
Phoenicians probably introduced mirrors into Italy in the sixth century BC,
and by the fourth century BC it became common for them to be engraved on
their reverses. In the Roman Period, high amounts of tin (15–27%) were added
to mirrors, and according to Pliny even serving maids could afford them. The
Romans understood optics and manufactured glass-fronted mirrors, some
with a tin backing. Today, when we are used to seeing ourselves reflected in
everything from bathroom mirrors to shop windows, it is not easy to realise
that this is a fairly recent phenomenon.

Further reading Nicholls, *Corpus Speculorum*, cat. nos. 7, 11; Thomson de Grummond,
Etruscan Mirrors, esp. chs. 3 and 7, pp. 180ff.

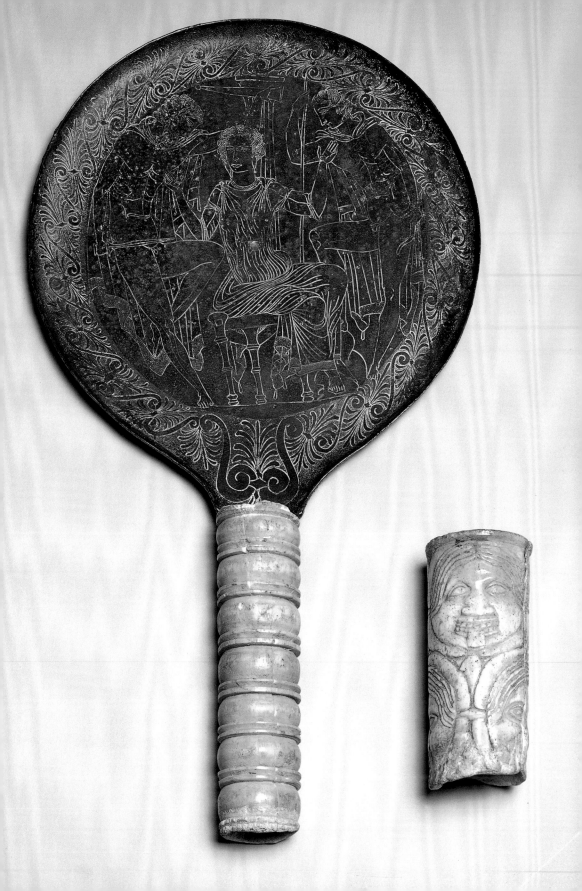

A FUNERARY COUCH

—

GR.3.1973 Bone.
Height (restored but without fulcrum) 63.6 cm, width 72 cm,
depth 48.5 cm. First century BC. Provenance unknown, possibly north Italy.
Purchased through the Cunliffe Fund and Victoria and
Albert Museum Grant-in-Aid.

Few pieces of ancient furniture survive, but we know something about what it looked like from representations in other media, such as from sculptures and in painted images (no. 24). This couch, used as a final bed of rest and probably from a tomb, is generally accepted as the finest surviving example of bone-decorated beds. It is thought that some bone beds might have been burnt on the funeral pyre. Surviving bronze beds or their elements (no. 34) are commoner and usually better-preserved.

This example was assembled in the Museum from fragments of decorated panels, figures and veneer pieces. Originally the bed was made of wood and secured with iron rods, and was clad in sculpted bone. From the further surviving fragments (not shown), it is clear that this bed was equipped with two *fulcra*-head-and-foot-rests, the former of which was larger than the end shown in the illustration. The *fulcrum* ends in a speculatively restored cupid head with glass inlaid eyes, facing in the direction of the finial. It could otherwise have been restored as a donkey's or horse's head. Much of the relief decoration is composed of acanthus, palmettes and lotus relief friezes. The frame terminates with a heavily draped *kithara*-playing Apollo whose copious drapery is arranged in patterns of an earlier period (archaistic). It is perhaps Turan, an Etruscan winged equivalent of the goddess Aphrodite, who is shown in the *pudica* pose reserved for the latter as she vainly tries to cover her breasts and pubis with a billowing drape which also acts as a space filler. The original materials used for the upholstery and interlacing are not known.

Further reading R. V. Nicholls, 'A Roman Couch in Cambridge', *Archaeologia*, 106 (1979), 1–32; Faust, *Fulcra*, cat. no. 66; G. M. A. Richter, *The Furniture of the Greeks, Etruscans and Romans* (London, 1966), pp. 105ff.

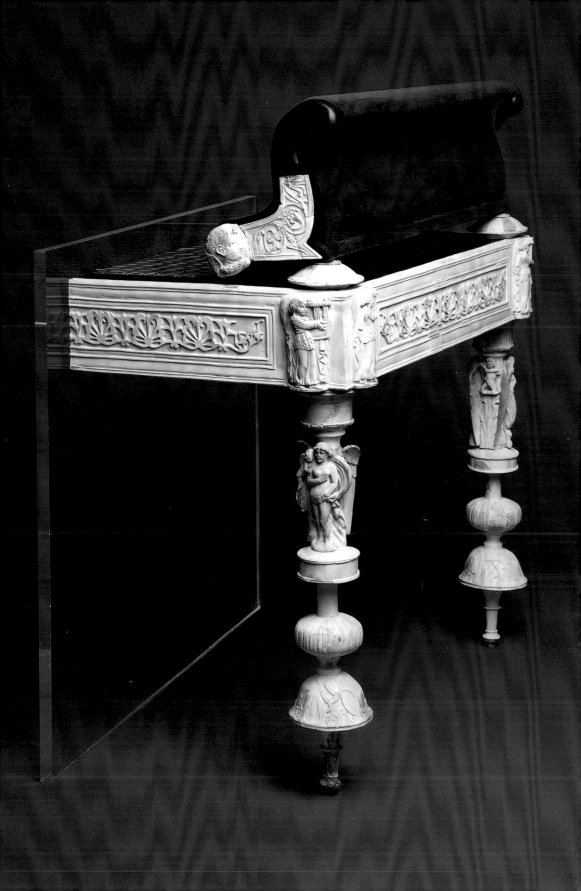

CYPRIOT HEADS

—

TERRACOTTA

GR.234.1888 *Bearded mature head. Height 10.1 cm.* GR.127.
1890 *Bearded head. Height 11.2 cm.* GR.8.1890 *Female bust. Height 14 cm.*
GR.134.1890 *Female veiled head. Height 10.8 cm.* GR.137.1890 *Female veiled head.*
*Height 10.3 cm. From Limniti and Paphos (*GR.234.1888 *only), Cyprus. Late*
fourth–second century BC. *Given by the Cyprus Exploration Fund.*

As we have noted, the Cypriots had a great tradition of producing votive stat-
uettes and statues of considerable size (no. 22). While assimilating Greek styles
in the Classical Period (nos. 30, 31), Cypriot coroplasts nevertheless continued
to produce large-scale terracottas according to their tradition. The votive
image was meant to perpetuate the prayer of the dedicant. However, from time
to time the need arose to free the sanctuary from the increasing numbers of
dedications, no doubt especially true with large-scale images, and therefore
the priests periodically cleared them away and buried them together in pits.

Before us is a range of large heads showing a varying degree of detail and
individual treatment. Although made in moulds, much detail was added after-
wards, such as wreaths, locks of hair, veils and jewellery. The stage of life of
the dedicant is suggested by means of mature beard or coiffure, but individual
treatment does not extend to showing signs of age or individual imperfec-
tions. Despite the particular arrangement of the hair and jewels, the faces are
essentially ideal images. The figures with the broad flat foreheads, and with
classical treatment of their eyes, which are not fully integrated into the face,
are earlier, whereas the thoroughly female central figure with rounded fore-
head and cheeks, deep orbitals and rosebud-shaped mouth could not possibly
be translated into a male one by the addition of a beard.

It is not clear how these came to be disembodied heads. It is not impossi-
ble that the heads were carefully buried, and the rest of the figures discarded
and thus not recovered by the excavators. Apart from one, all these heads were
found at a site serving a rustic population worshipping a Cypriot Apollo and an
eastern Aphrodite.

Further reading J. A. R. Munro and H. A. Tubb, JHS, 11 (1890), p. 98; J. B. Conelly, in
Uhlenbrock, *Coroplasts's Art*, pp. 94ff.

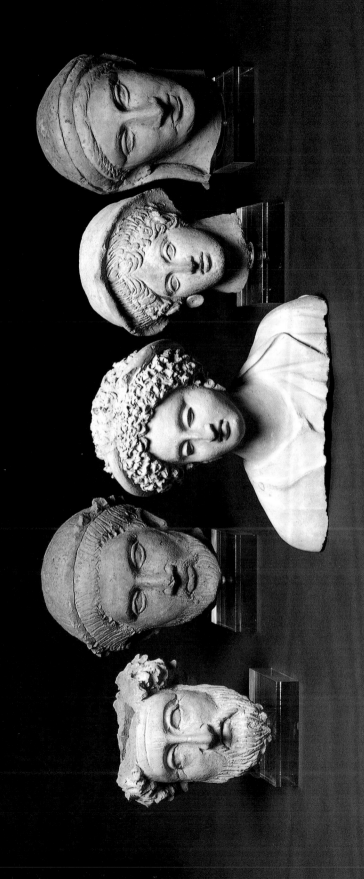

A SEATED CHILD

—

GR.1.1917 *Limestone with traces of red pigment.*
Height 31.5 cm, width 18 cm, depth 13.5 cm. C. 200 BC.
From Golgoi, Cyprus. Given by Marcus Huish.

Children were only infrequently represented in antiquity. Perhaps this is accounted for by a high mortality rate, resulting in a certain emotional distance being maintained between adults and children. In Cyprus there was a tradition of parents dedicating images of child votaries presenting offerings at the temples. Most are of boys in various stages of their lives: as babies, in military dress, and as young adults with wreaths. Baby girls were only rarely represented. The figures were usually in limestone – as marble needed to be imported – and frontally depicted. They range from one-third of, to more than, life-size, and have unworked backs since some were plastered into walls.

This child, probably of about two or three years of age, is seated on the ground, her right hand holding a dove offering which is perched on her raised right knee. In her lowered left hand she holds a piece of fruit. Her face is idealised and appears more adult than intended. Indeed it is the height and curvature of the forehead that actually signifies that this is the head of a small child. The combed wavy hair is gathered into a plait down the back, which is also a symbol of a toddler in antiquity. Nevertheless the child wears large, rope-like earrings and bracelets which in reality were probably gold and terminated in animal heads. Her crinkly *chiton* is girt by *periamma*-crossing-strings with the apotropaic Gorgon head at the chest (nos. 20, 33, 46). The back of the figure is only roughed out, apart from the plait. The asymmetric squatting position and diagonal tension folds in the garment act together with the gently turned and lowered head to relieve the frontality of the sculpture, which was generally avoided in monumental pieces of the Hellenistic Period.

Further reading J. B. Connelly, *Votive Sculpture of Hellenistic Cyprus* (Nicosia, 1988), ch. 1, fig. 9; C. Beer, *Temple-boys: A Study of Cypriote Votive Sculpture. Pt I: Catalogue* (Jonsered, Sweden, 1994), p. 85; L. Palma Cesnola, *Cyprus, its Ancient Cities, Tombs and Temples* (London, 1877), pl. xxxii:4.

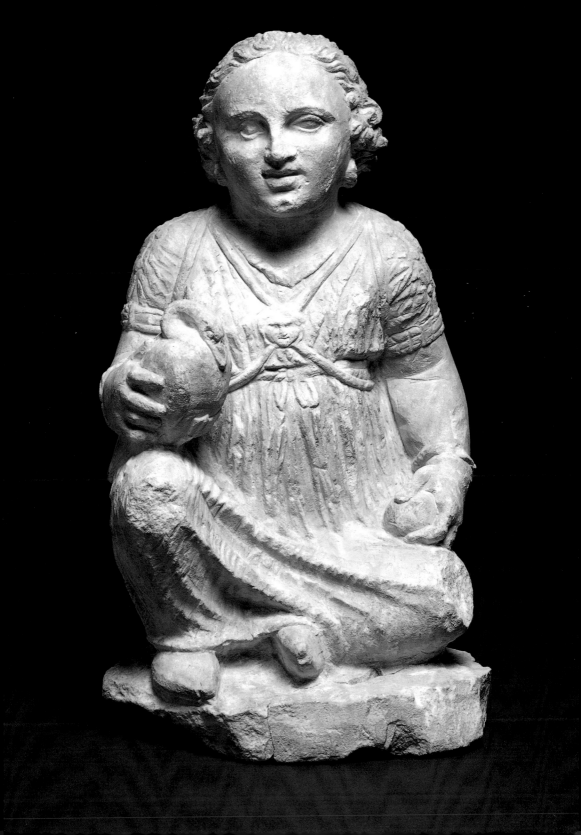

A CARYATID

—

GR.1.1865 Pentelic marble.
Preserved height 209 cm. C. 50 BC, from the
Inner Propylaea at Eleusis, Greece. Given by E. D. Clarke.

The idea of a maiden acting as an architectural support in place of a column is a Greek one, well known from the fifth century BC Erechtheion on the Athenian acropolis. This battered and worn caryatid bust, from the sanctuary at Eleusis near Athens, was mistakenly revered for centuries as the corn goddess Demeter herself (Latin Ceres), the mother who mourned her daughter's interment with the Lord of the Underworld for six months each year. The fallen architectural sculpture was first described by a traveller in 1676, and in 1801, despite its continued veneration by the locals who piled it round with manure, E. D. Clarke purchased it from the local governor and brought it by ship to England. Almost as if in divine retribution, the *Princessa* was wrecked off Beachy Head, but the sculpture was recovered. Eleusis was to turn into an industrial wasteland.

This caryatid is one of a pair which once flanked the entry-way to the sanctuary at Eleusis. Unusually for this type of architectural member, the present example shows a slight turn of the head to the left, and perhaps stood to the right of its pair. The maidens wear the *chiton*-garment and a ceremonial *diplax*-train pinned at the shoulders and bound by a figure-eight girdle with a Gorgon-head fastening (no. 45). Their arms were originally raised to grasp the feet of the sacred *cista*-vessel upon their heads, used in the ritual mysteries. Their thick tresses and attachment to a back pillar served as additional support. These caryatids represented the priestesses who led the annual procession of some 10,000 Athenians to Eleusis, which culminated in the secret mysteries. Appius Claudius Pulcher commissioned these figures for the Inner Propylaea in 54 BC. Clarke resisted the idea that this was a caryatid, but to his credit he also resisted the restoration favoured by his French contemporaries.

Further reading Budde and Nicholls, *Catalogue*, cat. no. 81; G. E. Mylonas, *Eleusis and the Eleusinian Mysteries* (Princeton, London, 1961), pp. 155ff.; G. Lloyd-Morgan, 'Caryatids and other Supporters', in M. Henig, *Architecture and Architectural Sculpture in the Roman Empire* (Oxford, 1990), pp. 143–151.

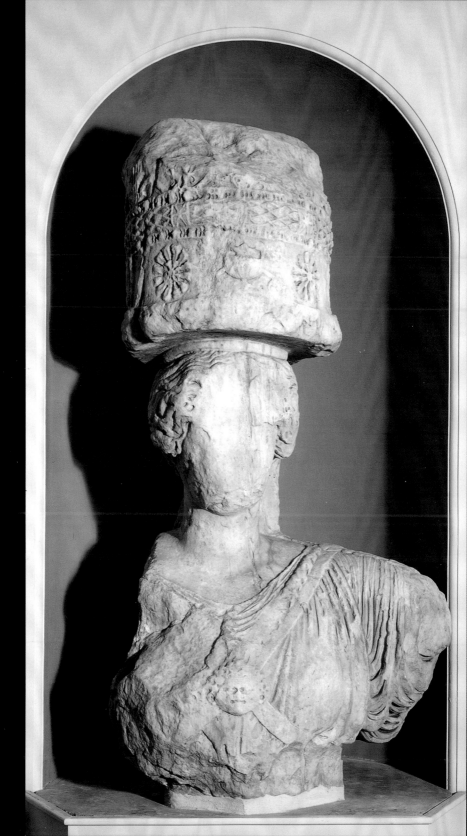

ANCIENT GLASS

—

GR.29.1912 *Trailed oinochoe. Height 10.7 cm.*
Bequeathed by C. B. Marlay. GR.93.1876 *Trailed amphoriskos. Height 15 cm.*
From Amathus, Cyprus. GR.1.1973 *Millefiori bowl. Height 4.1 cm.* GR.20.1917 *Gold band bottle. Height 9.2 cm. Formerly Forman Collection.* GR.23.1876 *Bottle with relief vases. Height 7.9 cm.* GR.61.1876 *Bottle with applied trailed decoration. Height 24.1 cm.*
From Marion, Cyprus. GR.21.1917 *Bottle. Height 7.9 cm. Formerly Forman Collection. Given with* GR.20.1917 *by C. Fairfax Murray.*
Fifth century BC *– second century* AD.

The ancient author Pliny the Elder recorded that glass was discovered accidentally in Phoenicia when merchants on the shore, needing some stones to support their cauldrons, used lumps of natron from the moored ship, which fused with the sand (probably quartz with calcium carbonate) in the heat of the fire. There may be a grain of truth in the story if the merchants were Egyptian, since natron was widely used there, but the earliest glass comes from Mesopotamia in the third millennium BC. Early glass was not transparent, and was coloured with the addition of various metallic compounds. Initially vessels were core-formed, the (clay and sand) core being dipped and turned in the molten glass. Decoration was applied by winding rods of different coloured glass around the still-soft vase and pressing them into the surface, then trailing the glass into patterns. Glass could also be mould-formed in open or piece moulds. From sometime in the first century BC, glass was blown or mould-blown into elaborate forms.

The present group represents a number of techniques developed over several centuries, the earliest being the small core-formed trefoil-spouted *oinochoe* of the fifth century BC, and the two-handled *amphoriskos* of the first century BC. The *millefiori*-mosaic glass bowl was built up from sections of glass rods shot through with other colours. The gold-band mosaic bottle was moulded and patterned with canes of glass and gold leaf in colourless glass. The mould-blown white bottle was formed in a three-part mould. Blown bottles could be transparent with applied decorative rods or assembled from blown lengths of coloured canes, here imitating agate.

Further reading Stern, *Mold-blown Glass*, pp. 37ff.; Grose, *Ancient Glass*, pp. 31ff., 339ff.

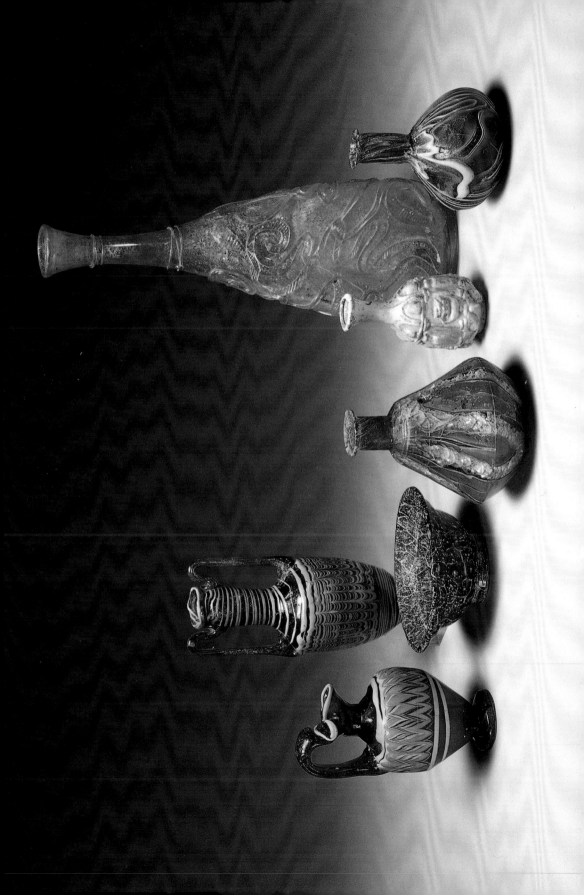

HEAD OF JUPITER

—

GR.16.1891 *Terracotta with traces of red pigment.*
Height 15.4 cm, width 12.2 cm, depth 11.2 cm. First–second century AD.
From the excavations at Lanuvium.

Beauty tells, regardless of the material, as in this fine terracotta head. One wonders why an artist in antiquity set out to produce such a masterpiece in what was a base and common material. Perhaps it was the advantages of malleability and supreme control which compelled the choice, perhaps a cost ceiling imposed by the patron. In any case, terracotta dedications were always suitable as a gift for the gods.

The head is an image of the chief god of the divine pantheon, Jupiter (Zeus to the Greeks). The Fitzwilliam Jupiter is startlingly modelled with a strong contrast between an ideal face and a highly plastic and baroque treatment of the hair and beard. In this generic portrait the eyes are almost naturalistically modelled, apart from the very artificial scored iris and sunken pupils. The lips are gently parted. The treatment of the back of the head is only sketchy, suggesting that the statue was integrated into its architectural surround and meant to be viewed only from the front. The seeming disarray of the hair and beard is actually quite formulaic and relates to other marble images of Jupiter or Zeus, which in turn also show an affinity with the well-known sculpture of Serapis (no. 50).

In an otherwise whingeing letter about the insolent behaviour of local officials and their relentless demands for bribes, the nineteenth-century excavator Sir Savile Lumley commented on the beauty and freshness of this piece, whose arms had also been found. He wrote that, had he not excavated the head at the site he mistook for the Villa of Caligula at Lanuvium, he would have thought it was modern.

Further reading L. Budde, 'Ein Zeuskopf im Fitzwilliam Museum zu Cambridge', *AA* (1952), pp. 101–123; B. H. Krause, *Iuppiter Optimus Maximus Saturnus* = Trierer Winckelmannsprogramme 5 (Mainz, 1983), pp. 13ff.

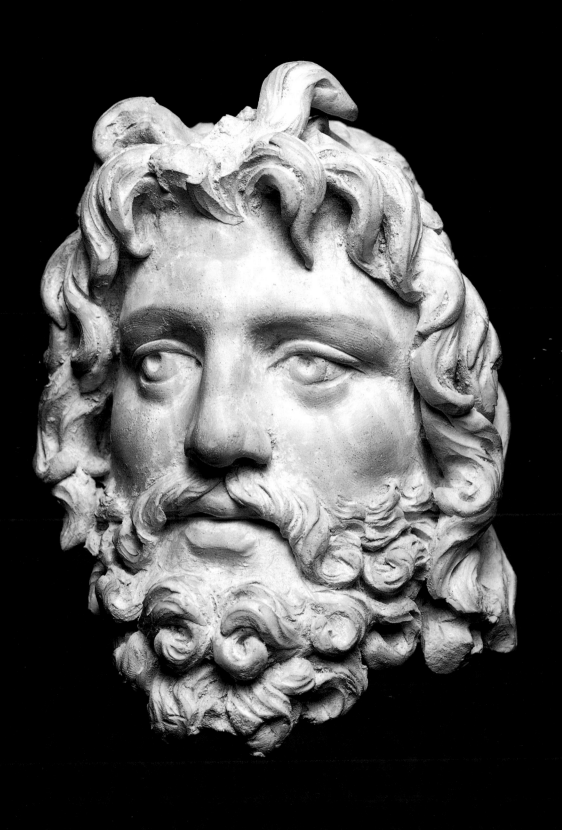

HERAKLES WRESTLING
ANTAIOS

◗

GR.4.1954 *Bronze.*
Height 14.5 cm, width 7.5 cm, depth 3.75 cm. First–second century AD.
From Egypt. Bequeathed by Sir Robert H. Greg.

During the Hellenistic Period artists began to explore narrative and genre scenes in sculptural groups. These usually illustrate the moment before the final action, and therefore suggest temporal suspense. The sculptors also considered the placement of sculptures and attempted to engage the viewer in moving around the sculpture. Popular large-scale images were translated into miniature sculptures in bronze and other materials and disseminated to the public on coins and engraved gems.

On his way through Libya to one of his twelve allocated labours, the hero Herakles encountered the giant Antaios, whom he wrestled and killed. Wrestling was a serious sport in Greece, and was first included in the eighteenth Olympiad (708 BC). Its invention was variously attributed to the god Hermes, to Theseus who wrestled Kerkyon and the Minotaur, and to Herakles who defeated a number of giants and beasts. Wrestlers fought naked and oiled in a sand pit and according to well-defined rules. Wrestling combined with boxing in the *pankration* was introduced to the Olympic Games in 648 BC.

We can easily recognise the bearded hero Herakles in a number of small-scale bronze sculptures derived from an architectural relief sculpture of the episode by the sculptor Praxiteles at Herakles' cult temple at Thebes. The giant Antaios is dwarfed here by the burly Herakles who has lifted him up above his shoulders in a waist-hold (*dialambanein*) before hurling him to his death.

The complicated subject is well suited to bronze. Such a group would have been difficult in a more fragile material like marble because the unbalanced posture of Antaios would demand additional struts.

Further reading Vollkommer, *Herakles*, p. 22; E. Spathari, *The Olympic Spirit* (Athens, 1992), pp. 124–136.

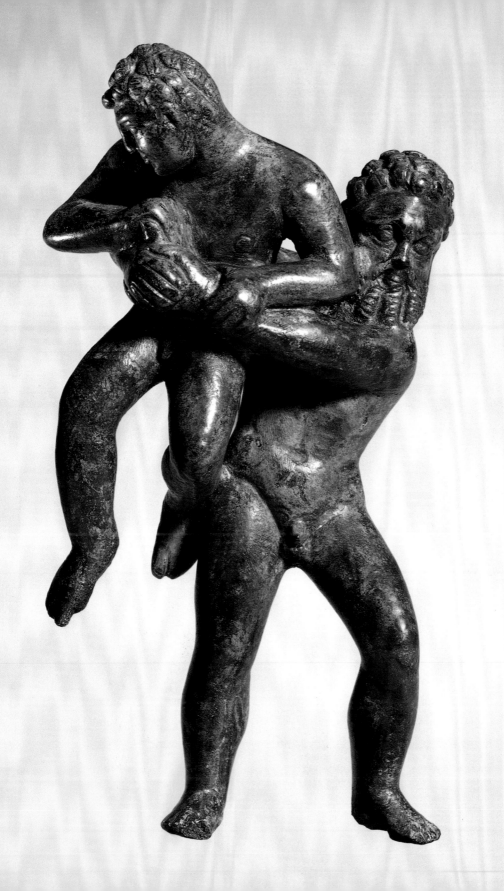

THE EGYPTIAN GOD SERAPIS

—

GR.15.1850 *Marble with restored modius and draped bust.*
Height 22 cm, width c. 16 cm, depth c. 13 cm. Second century AD.
Formerly Abbate Clementi (until 1752) and Thomas Hollis Collections.
Given by Dr John Disney.

Serapis was a composite deity combining the Egyptian Osiris, king of the
Underworld with fertility associations, and the living Egyptian Apis bull. The
god was introduced late in Egypt, probably by Alexander the Great (no. 33).
After conquering Egypt, Alexander visited the native Egyptian temples, and at
a place which later bore his name (Alexandria) encountered the divine duality
Osiris Apis. He immediately commissioned a temple to this deity. Alexander's
successor, Ptolemy I, dreamt that he was to import a god's *statue* from Sinope
to Alexandria. These events were confused in the literary tradition so that King
Ptolemy has always been credited with introducing the new *god* Serapis in
order to appeal to both the native Egyptian and the burgeoning Greek-speak-
ing immigrant population settling in Egypt. In any case, Serapis was a devel-
oping god who also became connected with Greek deities such as Hades of the
Underworld, Dionysos (no. 34), Asklepios (no. 29), Helios the sun, and even
Zeus, the father of all gods. Serapis' blessing was sought for children and the
sick, and he was regarded as a Saviour who spoke through oracles and in one's
dreams. The all-embracing nature of this newly syncretised god held much
appeal, and his cult was successfully exported to Rome.

In order to facilitate familiarity with the cult of Serapis, a statue was
commissioned from the sculptor Bryaxis, which may have relied on the statue
which King Ptolemy imported from Sinope. The most popular cult image of
Serapis shows him draped and regally enthroned, wearing his corn-basket
kalathos-crown over thick wavy locks, with the triple-headed beast Cerberos
seated at his side. The crown associated the god with the fruits of the earth,
and the beast, possibly confused with the Egyptian jackal deity Anubis, was
related to the god's role as conveyor of the dead. The present head is a second-
century copy from this popular sculpture.

Further reading Budde and Nicholls, *Catalogue*, cat. no. 57; J. E. Stambaugh, *Sarapis under
the Early Ptolemies* (Leiden, 1972), ch. 1.

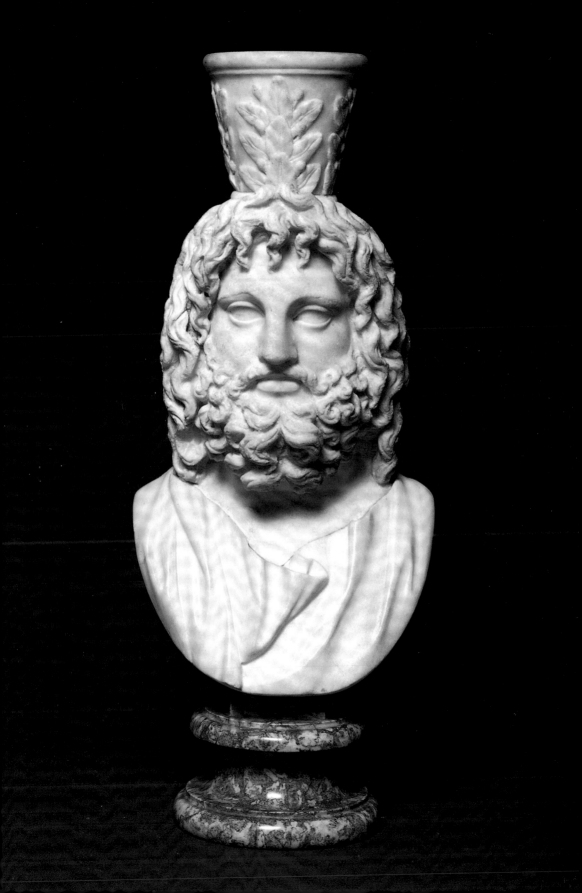

THE EGYPTIAN
GOD BES

●

GR.1.1818 Marble with restored parts of nose,
mouth and hands. Height 59.5 cm, width 28.5 cm, depth c. 27 cm.
After AD 130. From Rome, formerly in the Palazzo Verospi.
Given by A. E. Gregory.

Bes was an Egyptian god depicted as a grotesque, short and stout figure with leonine ruff and exaggerated negroid mask-like face. He was primarily a domestic deity who protected sleepers, mothers in childbirth, and also women from the jealousies of other women. His image was commonly worn as an amulet and it appeared on furniture in the boudoir. Bes was also associated with the mothering goddess, Hathor, and he acted as the music maker and dancer who assuaged her anger. On a more serious note, he was, especially in Roman times, a warrior god and had associations with the sun, which enabled him to be assimilated with a number of other deities. Although he had no traditional cult centre, he was venerated at a number of cities in the Roman period, among them Antinoopolis (no. 55).

This figure of Bes from Italy was probably sculpted there and not in Egypt, where marble was less common and where the few existing marble sculptures tended to be considerably smaller. Changes have occurred to the original iconography during the transmission from Egypt to Rome. Thus the god is shown with a smaller head and he has lost his leonine ears, his all-important ostrich-feathered crown, and enormous phallus. The loss also of his extended tongue is probably due here to an incorrect eighteenth-century restoration. The god's panther skin is not bound by a leather belt with a hieroglyphic knot as in Egyptian art but is prettified here with a beaded one, and he, like a limestone parallel in the Museo Barraco, wears an Italicised wolf amulet instead. The god being seated on a plinth once equipped with plumbing suggests that this Bes served as a fountain sculpture, something quite unthinkable for a god in ancient Egypt.

Further reading Budde and Nicholls, *Catalogue*, cat. no. 117; LÄ I, 720–724; LIMC III, 2, Bes 13.

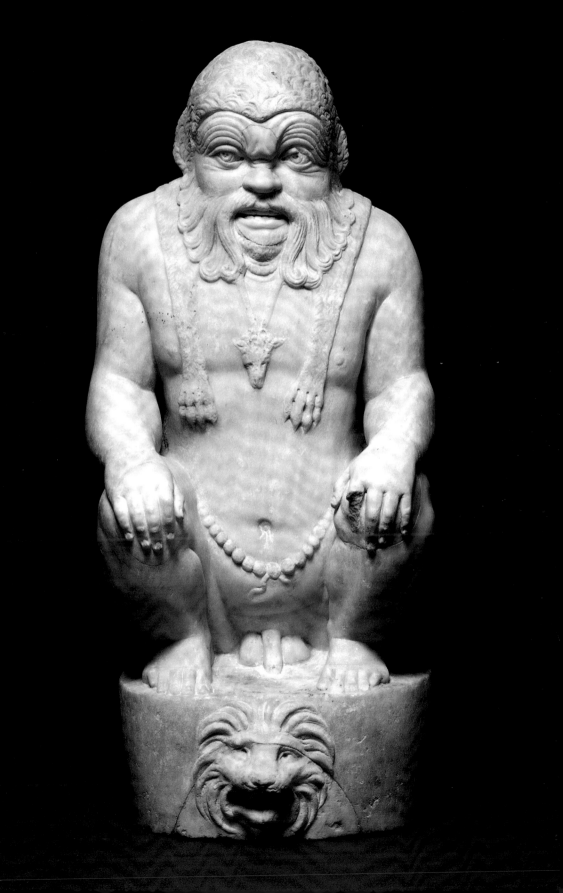

DIOSKOURIDES' GEM: HERMES

-

S 25 (CM) *Carnelian intaglio, modern ring.*
Height 16 mm, width 12 mm, depth 2.5 mm. C. 25 BC.
Formerly Orazio Tigrini (1585), Fulvio Orsini (1685), Baron Stosch,
Marlborough, Carmichael Collections. Bequeathed by
C. S. Ricketts and C. H. Shannon.

Dioskourides was celebrated in antiquity for having engraved the signet of Augustus. He is the only engraver named in antiquity whose work survives. Born in Cilicia, it is possible that he engraved gems for the Alexandrian court before migrating to Rome. He flourished from about 40 BC onwards. Recorded in the sixteenth century, this gem has passed through many esteemed collections, before coming to rest in the Fitzwilliam Museum.

Caught in a fleeting moment of time, the roadside, messenger and mercantile deity, Hermes, is appropriately shown here in his travelling *petasos*-hat and his heavy *chlamys*-cloak. He carries his *kerykeion*-standard and poses frontally in free space as if he is about to emerge from his carnelian matrix. The heavy ground line may allude to an actual statue on its base. Indeed, a marble sculpture with a wrongly restored head in the Vatican shows exactly the same draping and pose as this gem's impression. The sculpture is a copy of a presumably well-known sculpture of the mid fifth century BC. No doubt the classical symmetry of the sculpture appealed to Dioskourides, although he chose to challenge the classical proportions with a small head and fine limbs, and to introduce a greater swing to the hips in this *contrapposto*-pose.

Dioskourides produced three sons who kept his workshop and memory alive by including his name (patronymic) alongside their own on their engraved gems. It is possible that, in addition to intaglio and cameo gems, engravers in this period carved gold bezel rings, and cameo-cut glass such as the famous Portland vase in the British Museum, and they may have worked for the coin mints.

Further reading Henig, *Classical Gems*, cat. no. 165; M.-L. Vollenwider, *Die Steinschneidekunst und ihre Künstler in Spätrepublikanischer un Augusteischer Zeit* (Baden-Baden, 1966), pp. 56ff.; G. M. A. Richter, *Engraved Gems of the Romans* (London, 1971), pp. 129ff.

[actual size]

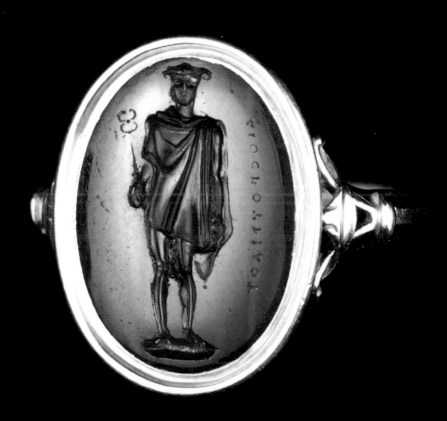

53

HEAD OF TIBERIUS

—

GR.115.1937 Frit. Height 7.2 cm, width 5.9 cm, depth 2.0 cm.
Formerly Wyndham Cook Collection. Bequeathed by
C. S. Ricketts and C. H. Shannon.

The Emperor Tiberius (AD 14–37) was somewhat coy about his own image and decreed that it should not be set up among those of the gods, but only among the ornaments of the temples. Nevertheless, his image is well known, especially through coins and cameos. Although middle-aged when he assumed the throne, Tiberius' image was based on that of Augustus and was purposely manipulated to appear young and to identify him more strongly as the adopted son and product of Augustus. In this magisterial, if small and ornamental, image of the emperor, presumably produced later in the reign, the more distinct Tiberian traits assert themselves in the high and broad forehead, the large eyes, aquiline nose and small curved mouth with protruding upper lip.

The compact material termed frit, made from quartz fused with alkali and coloured with green copper compound, is halfway between 'Egyptian blue' and glass. It was then part moulded and part carved. Frit was developed and used in Egypt, and, although cheaper than semi-precious gemstones such as turquoise, required great skill and experience from the artist. The medium enabled the coroplast-sculptor to produce the soft modelling of the gently fleshy face with an underlying hint of bone structure at the brow and with two shallow naso-labial furrows which suggest maturity. The subtlety of the face is heightened by the detailed and highly textured treatment of the hair which, however, was based on his earlier portrait type, which came into vogue on his adoption by Augustus.

This Tiberius image was meant as a relief boss, probably set into an object of contrasting material and colour, almost as a constructed cameo. The art of cameo cutting, first developed in Alexandria during the second century BC, became popular in Rome. Although Pliny the Elder described the introduction of glass gems as imitation ware for the masses, it was probably not this rare frit that he had in mind.

Further reading Henig, *Classical Gems*, cat. no. 538; Kleiner, *Roman Sculpture*, pp. 123–126; Kiss, *L'iconographie*, ch. 8.

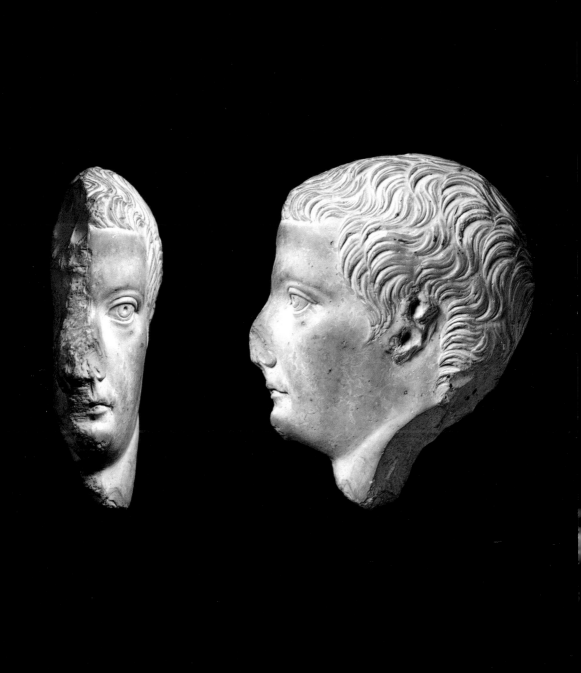

HEAD OF CALIGULA

~

GR.111.1937 *Copper alloy.*
Height 4.2 cm, width 3.5 cm, depth 4 cm.
AD. 37–41. *Provenance unknown. Bequeathed by*
C. S. Ricketts and C. H. Shannon.

In contrast to the relatively benign rule of Tiberius (no. 53), Caligula or 'little boot', so-called since childhood, was a depraved and murderous emperor who ruled for only four years (AD 37–41) before he and his family were assassinated. Unlike his predecessors, Caligula wished to be treated as a god in his lifetime, and even built a temple to himself. He fancied that he enjoyed a personal relationship with the god Jupiter (no. 48). His excesses were not to be forgiven, and so he was not deified by the Roman Senate after his death. Thus, few images survive of this short-lived emperor, who took the throne at the age of twenty-five and who desecrated the public sculptures of others.

While still conforming to the Julio-Claudian portrait type with high and broad forehead, thick mop of hair and protruding upper lip, Caligula's eyes are deeply set and close together. Unlike Tiberius, his nose is not aquiline, but thicker at the root and more bulbous at the tip. The unruly layers of curls on Caligula's portraits were meant to disguise his baldness, upon which it was an affront to gaze. The longish sideburns and hair on the nape of the neck, which became more pronounced as his portrait type developed later, were no doubt meant to compensate for this shortcoming. It is possible that this small bronze head, showing a certain tenderness and lacking the pronounced hardened features developed later which included a strong protruberant chin, comes early in the development of Caligula's image. Nevertheless, the head severed from the rest of the figure was possibly meant to be an item of worship set into an altar.

Further reading Kleiner, *Sculpture*, pp. 126ff.; J. J. Pollitt, *The Art of Rome* (753 BC–AD 337): *Sources and Documents* (London, New York, 1983), pp. 133ff.; Kiss, *L'iconographie*, ch. 13; Cleveland, *The Gods Delight*, pp. 278ff.

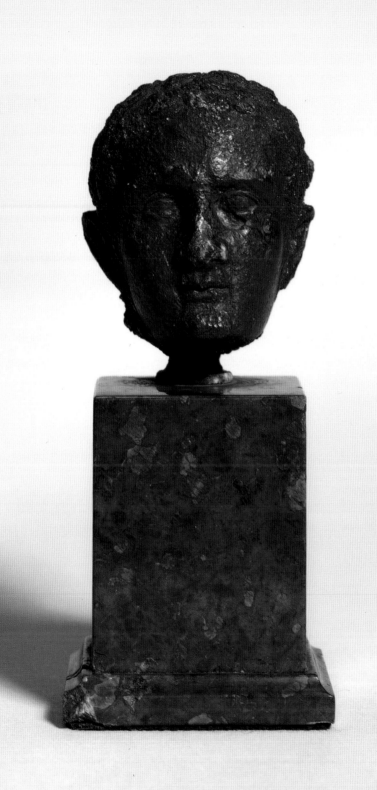

HEAD OF ANTINOOS

—

GR.100.1937 *Marble with restored nose, lips, chin,*
parts of wreath and bust. Height 41.0 cm. C. AD 130–140.
From Hadrian's Villa, Tivoli. Formerly in the Marquis of Lansdowne Collection.
Bequeathed by C. S. Ricketts and C. H. Shannon.

When the Emperor Hadrian visited Egypt (AD 130), he travelled with his male companion Antinoos, a youth from Bithynia. Antinoos drowned in the Nile, either accidentally or having offered himself up intentionally in order to satisfy one or another of Hadrian's superstitions. In keeping with the Egyptian tradition honouring those who died by drowning, his favourite was deified, and a prodigious number of cult images of Antinoos were set up all over the Roman Empire. The distraught emperor founded a city on the spot and named it Antinoopolis. There were festivals held every four years elsewhere at Mantineia, and also contests in honour of this young god, and he was depicted in the Mantineia gymnasium in the guise of the god Dionysos. It is thought that Hadrian also incorporated a hero's shrine (*heroon*) to Antinoos within his villa, populated with images of him, Egyptian and Roman gods, and also an obelisk.

When William, Earl of Shelbourne (later first Marquis of Lansdowne), made the 'Grand Tour' and visited Rome in 1771 as aristocratic young men did as part of their education, he made the acquaintance of the painter, antiquarian, and dealer Gavin Hamilton who was then excavating Hadrian's Villa at Pantanello. They agreed to create a collection that would make Lansdowne House the most famous in Europe. Five years later, Hamilton claimed to have excavated this colossal head of Antinoos, wearing the luxuriant locks and ivy wreath of the god Dionysos, from Hadrian's Villa. As was the custom of the period, the missing pieces were quickly restored, and the head was mounted on a modern bust, which was then smuggled out of Italy because a Papal licence had been denied.

Further reading Budde and Nicholls, *Catalogue*, cat. no. 109; C. W. Clairmont, *Die Bildnisse des Antinous* (Rome, 1966), p. 56, no. 55; H. Meyer, *Antinoos: Die Archäologischen Denkmäler unter Einbeziehung des numismatischen und epigraphischen Materials sowie der literarischen Nachrichten: Ein Beitrag zur Kunst- und Kulturgeschichte der hadrianisch-frühantoninischen Zeit* (Munich, 1991), pp. 116ff.

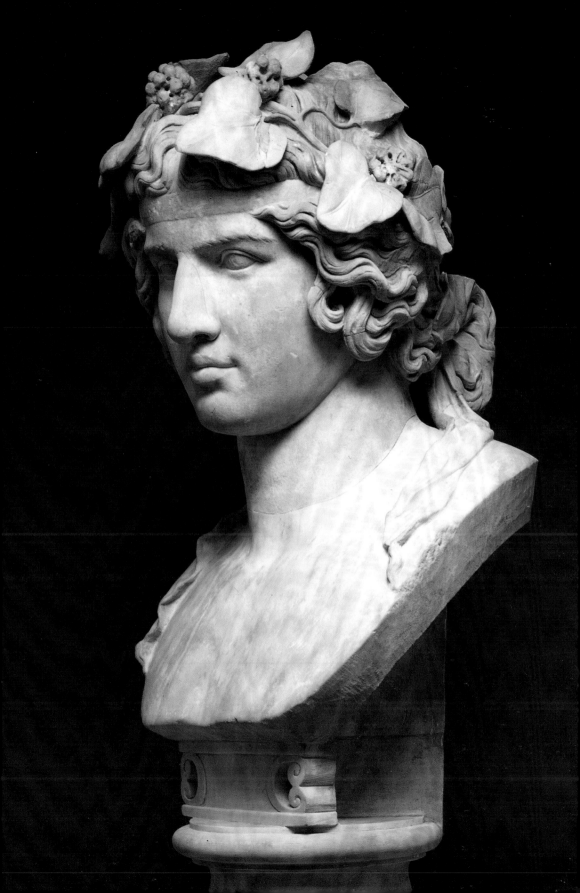

A DIONYSIAC SARCOPHAGUS

‒

GR.1.1835 *Marble (Luna). Length 222 cm, height 69.5 cm,*
depth 66.5 cm. C. AD 145–160. From Arvi, Crete. Given by Sir Malcolm Pulteney,
but the sarcophagus is named the 'Pashley Sarcophagus'.

The triumph of the god Dionysos, whose victorious return from campaigns at
the ends of the earth in Ethiopia and India coincided with spring, proved an
apt subject for the decoration of burial sarcophagi. In this beautifully com-
posed relief, the god of wine and intoxications, shown supported by a satyr,
arrives from the east in his centaur-drawn chariot. In his wake, a nymph plays
the *tympanon*-tambourine. The centaur couple hold up the procession by their
embrace. Further along, goat-legged Pan rapturously plays his *tympanon* near
an uncooperative drunken old Silenus who has dropped his massive drinking
cup. Beyond, a satyr with small child follow up the drinking maenads (and
Ariadne?) and satyrs borne by the elephant, symbol of triumph. The final
figure is that of a satyr, who steadies himself under the weight of a wine skin as
he straddles a panther. The lid shows a continuous frieze in lower relief of
nymphs and satyrs feasting on skin-bedecked couches.

This seemingly debauched procession and feast above had profound
meaning in antiquity, in particular for the well-organised initiates of the cult
of Dionysos who, dressed for the roles, re-enacted these events annually in
spring in a celebration of the renewal of life. The subject of the triumphal pro-
cession was a popular one. Indeed, the chaotic motifs appear repeatedly,
sometimes altered, but often in a changed sequence. Thus the marriage of
Dionysos with Ariadne is occasionally conflated with his triumph; alone or
together with his spouse he could appear in a panther- or centaur-drawn
chariot. The elephant, used in processions of conquerors and in Imperial rites
of divinity, symbolising triumph and eternity, was often shown carrying
foreign slaves. The changing proportions of the figures between the scantily
clad maenad and the smaller Dionysos, and between the child-bearing satyr
and the silen-supporting nymph, may show that the motifs were derived from
different pattern books. Their insertions required some scaling down for the
sake of the composition, and manipulation as in the case of the implausibly
reclining satyr at the right end of the lid.

Further reading Budde and Nicholls, *Catalogue*, cat. no. 161; F. Matz, *Die antiken*
Sarkophagereliefs II (Berlin, 1968), pp. 212ff., 245ff., cat. no. 129; K. Lehmann-Hartleben
and E. C. Olsen, *Dionysiac Sarcophagi in Baltimore* (Baltimore,1942), pp. 20ff.

AN IVORY TREASURE

—

GR.2–27c.1980 *Box with sliding lid.*
Cylindrical pyxis-vessel (height 8.0 cm, diameter 10.2 cm).
Vessels. Tray (length 21.5 cm, width 9.8 cm). Bowl, combs, fan (?), another box and
pyxis. Sword-shaped spatula (length 20.0 cm). Writing tablets, sandal-shaped
(length 18.5 cm, width 5.3cm). Papyrus stand and knobs. First century AD.
Provenance unknown, perhaps Italy (?). Purchased through the Gow, Greg,
and Hitchcock Funds, and through the Victoria and
Albert Museum Grant-in-Aid.

We are used to imagining treasures being made of gold, but when we consider how remote ivory was to the Roman craftsman working, for example, in Italy, we get an idea of the preciousness of this material. Presumably belonging to a lady, this treasure might have been packed into a large *cista*-container (no. 41) and placed in her tomb. Part of the treasure represents objects of her toilet, the operative word being represents, since some of the vessels are so small. One wonders whether these were models of actual objects. The scent bottles are made as miniature storage jars and flasks. The boxes with sliding lids and the miniature cylindrical *pyxis*-vessel could not have functioned in anything but a magical sense. This may also be true of the fan-shaped object, which may actually represent a mirror, since it is not robust enough to have functioned as a fan. The tray and larger *pyxis* could not even have been packed with much of the treasure itself. If they were meant to be used, the combs would have required great care to avoid breakage.

Part of the treasure relates to literacy, equipped as it is with two pairs of wax writing tablets, one of which is elegantly sandal-shaped, along with a mechanism thought to be used for un-rolling and reading a papyrus roll. It is not clear whether the knife-shaped spatula was meant for cosmetic purposes or whether it was intended for smoothing papyrus or the waxed writing tablets. In any case, the message conveyed by this tomb group is one of affluence, elegance and intelligence.

Further reading Bordenach Battaglia, *Le ciste*, p. 67.

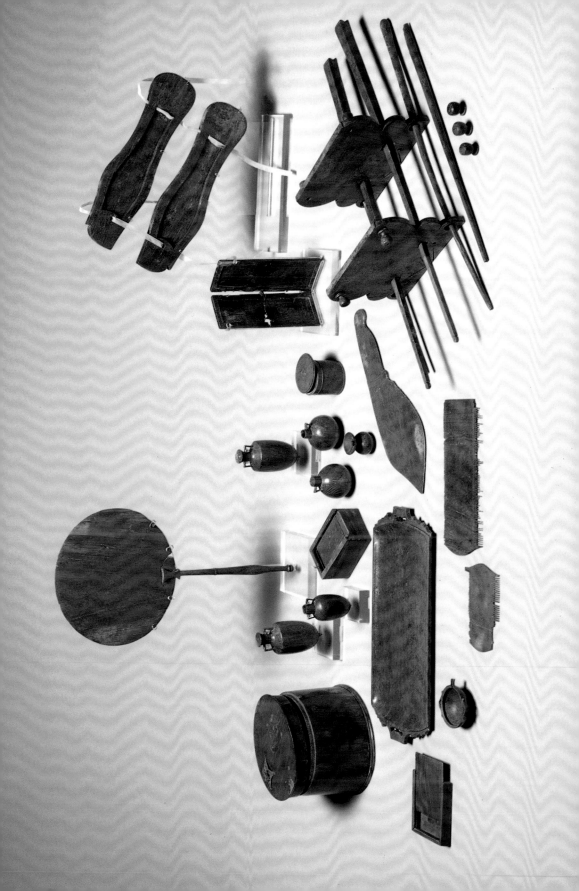

CHILD PORTRAIT CAMEO

—

GR.114.1937 Chalcedony.
Height 57 mm, width 38 mm, depth 25 mm. C. AD 169 (?).
Formerly Wyndham Cook Collection. Bequeathed by
C. S. Ricketts and C. H. Shannon.

Occasionally, ancient cameos were carved in relief so high they are seemingly in the round, as with this chalcedony bust of a child whose head is virtually free, whereas he is shown in low relief from the neck down. Once mounted in a jewel, this figure formed a kind of small shrine of a deified child which was probably meant to be worn. This type of cameo was certainly executed by an Imperial gem carver to be presented as a royal gift to a family member or to a close friend.

The cherubic child is shown with a full and asymmetric face, thickly lidded eyes but fine and arching brows which endow him with an otherworldliness. His hair is neatly combed forward and his bust is fully enveloped by a garment with an assortment of pine cone, ear of corn, leaf, bunch of grapes and fruits placed over his crossed hands. The child may represent a season and therefore a desire for revivification, motifs often appearing on sarcophagi. Because of the fruits he may be associated with Dionysos and a similar hope (no. 56). The particular treatment of the face suggests that this is a portrait. A likely candidate is Annius Verus, son of Marcus Aurelius, who took the throne with his older brother Commodus in AD 166 but who died in AD 169 at the age of seven and was seemingly heroised on coins. The background field, mostly cut away when the gem was probably remounted, is decorated with incised leaves, and not wings as was once thought. Perhaps the leaves were meant to refer to the bier.

Further reading Henig, *Classical Gems*, cat. no. 540. M. Henig, in M. Henig and M. Vickers, eds., *Ancient Cameos in the Content Family Collection* (Oxford, Houlton, 1993), pp. 32ff.

DEITY WEARING A TOGA

—

GR.7.1912 *Copper alloy. Height 18.7 cm, width 11 cm.*
C. second century AD. *Bequeathed by C. B. Marlay.*

Respectable Roman male citizens were entitled to wear the toga when they reached the age of majority. It was an expensive garment whose draping required assistance, and was normally worn when setting out for town or for official engagements. *Togatus capite velatus* figurines, invariably in bronze, were usually equipped with an offering vessel in the right hand, a cornucopia, an incense box or a *rotulus*-book roll in the left hand. These are referred to as genius deities, a Roman concept that began as the procreative power and developed into the essence of man. The Romans also believed in the genius of places, things, and even of the Roman people. It is not clear, however, whether these particular figurines were meant as the generic genius of a family ances-tor or whether they referred to Augustus as genius of the Roman *populus*. If the latter, the effect was to show him in his capacity as High Priest, humbly making an offering on behalf of his household, the Roman Empire. Nevertheless, we might then expect a more particular representation of the emperor. The absence of the cornucopia, certainly not to be reconstructed here, may distinguish this figure as the image of the *paterfamilias* and not as a genius of the populace. Genius figures were often set up alongside an image of the household deity, Lars, in a niche altar within the home. Examples date from the first and second centuries AD.

A fine hollow casting now pocked by corrosion, the Fitzwilliam genius still reveals a sharpness of modelling and an acute interest in detail. The eyes were once silvered and inlaid for a startling image, the hands and attributes were separately fashioned and attached for a lifelike effect. Although missing, the attributes might be reconstructed as the offering vessel in the right hand and the census box in the left. The genius suffered from bronze disease (a type of progressive corrosion) due to storage in a damp Welsh cave during the Second World War.

Further reading D. K. Hill, in AJA, 72 (1968), p. 166; H. G. Niemeyer, *Studien zur statuar-ischen Darstellung der römischen Kaiser* (Berlin, 1968), pp. 44ff.; H. Kunckel, *Der römische Genius* = RM-EH 20 (Heidelberg, 1974), pp. 11ff., cat. no. F I 16.

ORANT ON A DIVAN

—

E.1.1995 Terracotta with plaster wash and red pigment.
Height 16.7 cm, width 12.2 cm, depth 6.8 cm. First century AD.
Said to come from the Fayum, Egypt. Formerly Fouquet Collection.
Purchased through the Greg Fund.

Roman antiquities from Egypt have often been overlooked both by Egyptologists interested only in pharaonic art and by Classicists only concerned with mainstream art. However, a wealth of evidence survives from Roman Egypt as regards material culture, including ancient texts and documents relating to marriage and divorce, inheritance, properties and taxes. Two cultures, the one Egyptian and steeped in pharaonic tradition, the other essentially Greek, had co-existed since the conquest by Alexander the Great (no. 33). Little by little, the Greek-speaking inhabitants began assimilating eastern and Egyptian customs and beliefs.

As we have seen, the distinction between votary and votive is often unclear (nos. 2, 8, 9, 12), but, in the east, the tendency was to show a votary as an orant with hands raised, palm outwards, as a sign of prayer. Nevertheless, female terracotta orant figures from Egypt shown seated were often ambiguously regarded as concubines of the dead on account of their occasional nudity. It was thought that the legs were regularly atrophied so that the companion could not escape the advances of the dead. However, in this rare composition, a fine Egyptian lady wears a tunic with red borders, an enormous stepped coiffure, a large garland around her neck, and she is seated on a divan before a small tripod table set with food. This is undoubtedly the image of the deceased before her repository table, addressing the prayer of the dead to her god. The composition was made by pressing it frontally into a mould and by completing the back by hand. It is hollow and, like most Egyptian terracottas, is equipped with an additional hole at the back, possibly for hanging. The subject and the strong frontality of the figure is very unlike the Hellenistic 'Tanagra' tradition (no. 39).

Further reading W. Weber, *Die ägyptisch-griechischen Terrakotten* I (Berlin, 1914), pp. 143ff., cat. no. 229; L. Török, *Hellenistic and Roman Terracottas from Egypt* (Rome, 1995), pp. 127ff.; F. Dunand, *Catalogue des terres cuites gréco-romaines d'Egypte* (Paris, 1990), pp. 202ff.

A NEW COMEDY MASK

—

E.33.1982 Red faience.
Height 6.7 cm, width 4.8 cm. C. second–third century AD.
Provenance unknown, perhaps Egypt (?). Given by
the Wellcome Trustees.

Masks were worn by actors on the ancient stage as a means of distinguishing the *dramatis personae*. Developed from Middle Comedy, New Comedy focussed on love stories both mythological and real, and involved a number of stock figures known to us from extant plays and a later compilation of the second century by Pollux. Although the plays were mostly serious and moralising in tone, New Comedy figures included conservative gentlemen, raffish sons, women of different classes, 'scarlet' women, soldiers, parasites and slaves. Masks, which were made of wood or stuccoed linen, might show a meddlesome character by means of one raised eyebrow, or a sharp one with both raised brows, whereas a servant might be cross-eyed. The shape of the beard and nose, the colour of the skin and the type of dress would aid identification.

This miniature mask was produced in a silicious material termed faience, of which the finest quality was produced in Egypt. The deep reddish-purple colour was probably also meant to evoke the hard stone porphyry quarried in Egypt and sent all over the Roman Empire as a luxury material for buildings and imperial sarcophagi. The faience could be mould-made, followed by further detailed tooling. It is not clear what the function of this mask was, other than as some sort of decorative boss. Due to the lack of a beard, it is possible that this mask was meant to portray a young and possibly lovelorn man.

Further reading T. B. L. Webster, *Monuments illustrating New Comedy*, 3rd edn rev., 2 vols (London, 1995), I, pp. 2ff., II, pp. 395ff., 478ff.

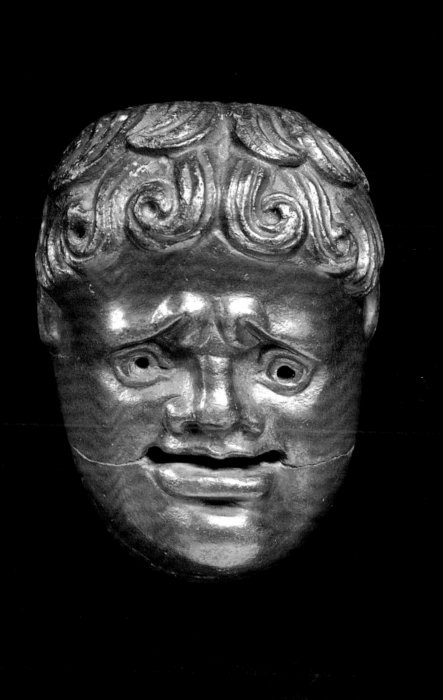

62

A PEN-KNIFE

—

GR.1.1991 *Silver and iron.*
Length (bowl to fork) 13.6 cm, length of handle 8.2 cm,
width of same 2 cm. Third century AD. *Formerly Roper Collection.*
Purchased through the Greg Fund.

Just as one today might pack a folding pen-knife before setting off on a journey, so too Romans were known to carry folding knives and spoons, their most commonly used eating implements by the first century AD. After the Second Punic War, when the Romans gained access to the Spanish silver mines, plate was mass-produced so that silver collecting became a common pastime among the patrician class. Ancient textual anecdotes suggest large silver workshops and silver was owned even by slaves. Common though it was, silver was nevertheless frequently buried in hoards to avoid discovery by barbarian invaders throughout the late Roman Empire.

Only a handful of examples of elaborate folding pen-knives such as this one are known, and each is unique in type. Here, the spoon handle terminates in the rare instance of a Roman fork which is trident-shaped. The whole is connected by a hinge to a lyre-openwork handle equipped with a rivet to lock the fork against the handle. A corroded iron blade and three further smaller silver implements fold into the handle. The precise functions are not certain, but perhaps the spike with a lever opened crustaceans, the small spoon was for scooping up seasonings, and the leaf-shaped implement was for picking the teeth.

Further reading D. Sherlock, in AntJ, 68 (1988), 310–311, pl. xlix; H. A. Cahn and A. Kaufmann-Heiniman, *Der spätrömische Silberschatz von Kaiseraugst* (Basel, 1984), I, p. 124 where a medical use is suggested; II, pl. 33: 1–3; D. E. Strong, *Greek and Roman Gold and Silver Plate* (London, 1966), chs. 2, 7.

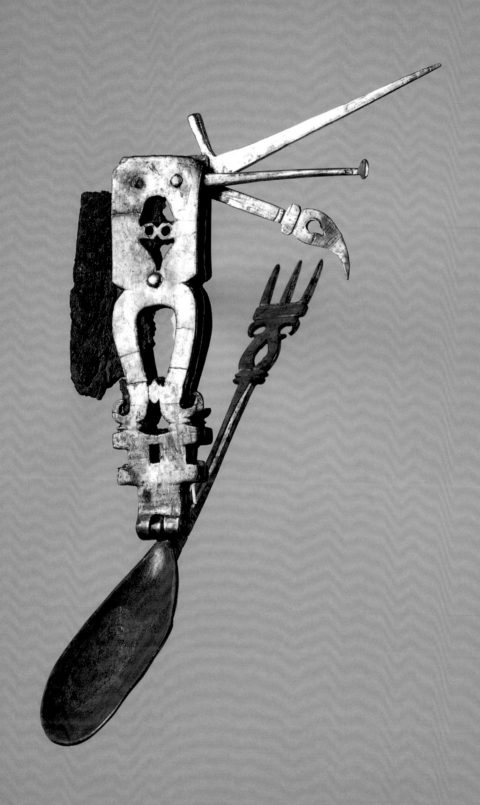

ANCIENT DRESS

—

E.T.26 Tunics. Linen with wool embroidery.
Length 62.8 cm. E.T.27 Length 42 cm. E.T.98 Length 77 cm. E.58.1911 Hat.
Embroidered silk, cotton lining. Diameter 12.5 cm. E.T.109 Headscarf. Linen and wool.
Length 64.5 cm. EGA.4335.1943 Slippers. Leather uppers and soles. Length 12 cm.
Given by R. G. Gayer-Anderson. From Egypt. Fourth–sixth century AD.

Thanks to the dry climate in Egypt many ancient garments have been preserved until today, although most are fragmentary. Numerous panel paintings of the dead (so-called Fayum portraits) are also extant, showing what the average citizen of the Roman Period wore. Essentially almost everyone was decked out in mostly long-sleeved, knee- or ankle-length tunics. These were usually unbleached linen for men and dyed pink or purple for women, and both had embroidered decoration in dyed wool. The tunics could be worn in layers along with a mantle. We are less sure about the types of headdress that were worn, mainly because adults were keen to have themselves represented wearing the hairstyles of the period, usually in the manner of the Imperial court. Women also did not wish to obscure their bejewelled ears and neck. Leather shoes and sandals are preserved from Egypt, where palm-frond sandals were also worn.

Tunics were normally woven cuff to cuff with a neck-opening slit, with vents under each arm, and often with tapered sleeves. They could be woven in one piece, as was the medium-sized garment shown here, or in two, as was the large one which has a separate tube from the waist, or sewn from a cut piece, as was the smallest-sized garment represented. The decoration was usually composed in *clavi*-vertical bands from either shoulder or in geometrical blocks. Here we see isolated poppy buds, floral frieze *clavi*, and zones of meandering vine, probably derived from the imagery of Dionysos, god of wine. Silks such as the cap shown here became popular before, and all-woollen tunics after, the Arab conquest (seventh century AD).

Further reading B. Borg, in E. Doxiadis, *The Mysterious Fayum Portraits. Faces from Ancient Egypt* (London, 1995), pp. 234ff.; S. Walker and M. Bierbrier, *Ancient Faces. Mummy Portraits from Roman Egypt* (London, 1997), pp. 176ff.

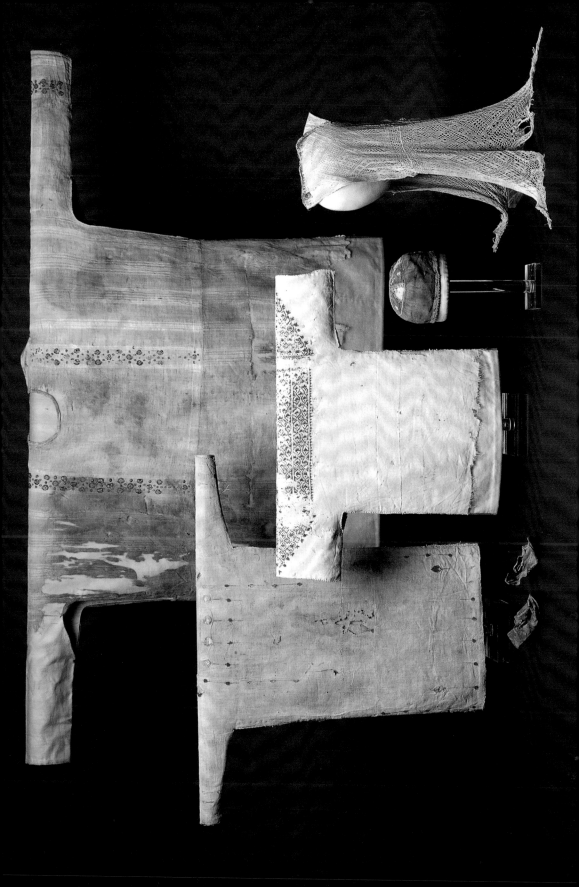

MOSAIC NICHE

◆

GR.159.1910 *Mosaic of coloured glass, veined marbles,*
diamond rosso antico and shells. Minor restorations of tesserae and shells.
Height 112 cm, width 80 cm. C. 50–75 AD. From Baia (near Naples), Campania.
Formerly Ponsonby Collection. Given by M. Marks.

The Roman wall vault was not merely an architectural conceit, but was meant to represent a grotto and the source of springs which were under the protection of nymphs. Wall vaults were introduced during the reign of the Emperor Augustus (30 BC–AD 14), and were initially decorated with pumice and shells in a purposeful association with nymphs. Mosaic decoration, which offered the advantage of stronger colours than painted surfaces, and a waterproof surface, were introduced in the time of Nero (AD 54–68). The artisans, who were highly skilled, probably worked to cartoons transferred to the plaster background onto which they set coloured glass *tesserae*. It is thought that mosaic wall vaults acquired the name *opus museum* because philosophers and poets taught about their arts under the guidance of their muses in cool underground buildings equipped with piped water-fountains in wall vaults.

This mosaic wall vault shows the customary shell pattern on the bowl of the vault and is indeed articulated above the drum by embedded shells which also frame the base and entire edge of the vault. The drum shows a leafy garden punctuated by three birds about to perch. A more ornamental peacock is carefully centred on a low garden wall at the bottom of this idyllic scene near the base of the drum. The ancient poet Horace revealed one of his desires: 'a plot of land not so very large, which should have a garden and a spring of ever-flowing water near the house, and a bit of woodland as well'.

Further reading W. F. Jashemski, *Gardens at Pompeii* (New York, 1979), pp. 41ff., fig.108; F. Sear, *Roman Wall and Vault Mosaics* = RM-EH 23 (Heidelberg, 1977), pp. 17ff., cat. no. 47, pl. 28.

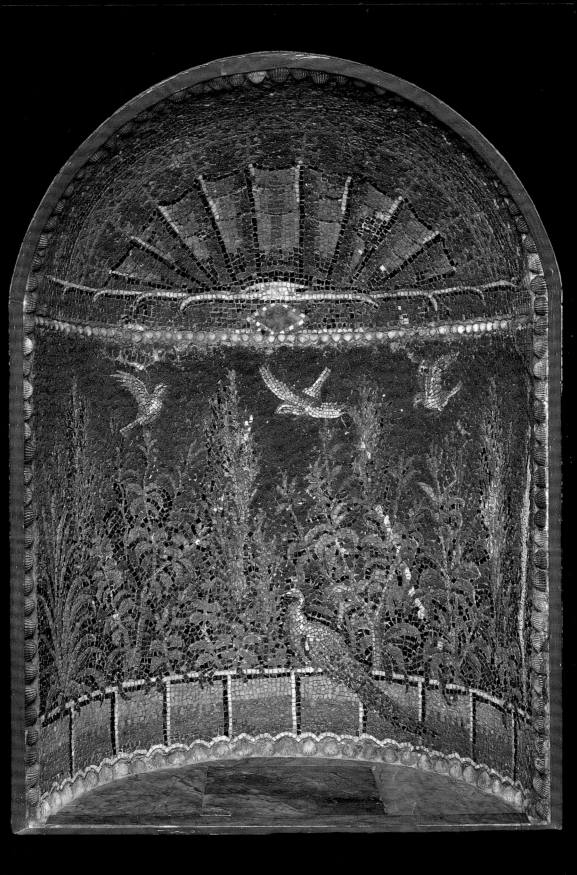

SELECT BIBLIOGRAPHY
AND ABBREVIATIONS

AA: *Archäologische Anzeiger*.

ActaArch: *Acta archaeologica* (Copenhagen).

AJA: *American Journal of Archaeology*.

AntJ: *The Antiquaries Journal. The Journal of the Society of Antiquaries*.

ABV: Beazley, J. D. *Attic Black-figure Vase-painters*. Oxford, 1956.

ARV²: Beazley, J. D. *Attic Red-figure Vase-painters*. 2nd edn. 3 vols. Oxford, 1963.

BABesch: *Bulletin antieke beschaving*. Annual papers on classical archaeology.

Beazley Addenda: additional references to *Attic Black-figure Vases, ARV²* and *Paralipomena*.
 2nd edn compiled by T. H. Carpenter *et al*. Oxford, 1990.

Boardman, J. *Pre-Classical. From Crete to Archaic Greece*. Harmondsworth, 1967.

Boardman, Attic Red-figure Vases: Boardman, J. *Attic Red-figure Vases: The Archaic Period*.
 London, 1975.

Boardman, Greek Gems: Boardman, J. *Greek Gems and Finger Rings. Early Bronze Age to Late
 Classical*. London, 1970.

Boardman, Greek Sculpture: Boardman, J. *Greek Sculpture: The Late Classical Period*. London,
 1995.

Bonfante, L. Ed. *Etruscan Life and Afterlife. A Handbook of Etruscan Studies*. Warminster,
 1986.

Bordenach Battaglia, Le ciste: Bordenach Battaglia, G., with A. Emiliozzi. *Le ciste
 Prenestine* I, Corpus I. Florence, 1979.

Brendel, O. J. *Etruscan Art*. New Haven, 1995.

BSA: *Annual of the British School at Athens*.

Budde and Nicholls, Catalogue: Budde, L., and R. V. Nicholls. *A Catalogue of the Greek and
 Roman Sculpture in the Fitzwilliam Museum*. Cambridge, 1967.

Buranelli, F. *The Etruscans, Legacy of a Lost Civilization*. Memphis, 1992.

Charbonneaux, J. *Greek Bronzes*. Trans. K. Watson. London, 1962.

Cleveland, The Gods Delight: Cleveland Museum of Art. *The Gods Delight. The Human Figure
 in Classical Bronze*. Cleveland, 1988.

Coldstream, J. N. *Geometric Greece*. London, 1977.

Comstock, M. and C. Vermeule. *Greek, Etruscan and Roman Bronzes in the Museum of Fine
 Arts Boston*. Boston, 1971.

Cook, Painted Pottery: Cook, R. M. *Greek Painted Pottery*. 3rd edn. New York, 1996.

CVA: *Corpus Vasorum Antiquorum*: Great Britain: Cambridge 6:1; 11:2. Oxford, London and
 Paris, 1930; 1936.

Dickinson, Aegean Bronze: Dickinson, O. *The Aegean Bronze Age*. Cambridge, 1994.

Faust, Fulcra: Faust, S. *Fulcra: Figürlicher und ornamentaler Schmuck an antiken Betten* = RM-
 EH 30. Mainz, 1989.

Finley, M. *Early Greece: The Bronze Age and Archaic Ages*. London, 1970.

Fitton, J. L. *Cycladic Art*. London, 1989.

Fitton, *Cycladica*: Fitton, J. L. Ed. *Cycladica. Studies in Memory of N. P. Goulandris*. London, 1984.

Frankfurt, *Polyklet*: Frankfurt Liebieghaus. *Polyklet. Der Bildhauer der griechischen Klassik*. Frankfurt, 1990.

Getty, *Small Bronze Sculpture*: The J. Paul Getty Museum. *Small Bronze Sculpture from the Ancient World. Papers Delivered at a Symposium... March 16–19, 1989*. Malibu, 1990.

GettyMusJ: The J. Paul Getty Museum Journal.

Grose, *Ancient Glass*: Grose, D. F. *Early Ancient Glass: Core-formed, Rod-formed and Cast Vessels and Objects ... 1600 BC to AD 50*. New York, 1989.

Haynes, *Technique*: Haynes, D. *The Technique of Greek Bronze Statuary*. Mainz, 1992.

Henig, *Classical Gems*: Henig, M., et al. *Classical Gems: Ancient and Modern Intaglios and Cameos in the Fitzwilliam Museum Cambridge*. Cambridge, 1994.

Higgins, *British Museum*: Higgins, R. A. *Catalogue of the Terracottas in the Department of Greek and Roman Antiquities, British Museum* I. London, 1954.

Higgins, *Greek Terracottas*: Higgins, R. A. *Greek Terracottas*. London, 1967.

Higgins, R. A. *Minoan and Mycenaean Art*. New York and Washington, 1967.

Higgins, *Plastic Vases*: Higgins, R. A. *Catalogue of the Terracottas in the Department of Greek and Roman Antiquities in the British Museum* II: pt 1, *Plastic vases of the Seventh and Sixth Centuries BC*. London, 1959.

Hood, S. *The Arts in Prehistoric Greece*. Harmondsworth, 1978.

Hood, S. *The Minoans. Crete in the Bronze Age*. London, 1971.

Hunt, D. Ed. *Footprints in Cyprus: An Illustrated History*. Revised edn. London, 1990.

JdI : Jahrbuch des Deutschen Archäologischen Instituts.

JHS: Journal of Hellenic Studies.

Karageorghis, *Coroplastic Art*: Karageorghis, V. *The Coroplastic Art of Ancient Cyprus* II: *Late Cypriote II–Cypro-Geometric III*. Nicosia, 1993.

Karageorghis, V. *The Coroplastic Art of Ancient Cyprus* III: *Cypro-Archaic Period Large and Medium Size Sculpture*. Nicosia, 1993.

Kiss, *L'iconographie*: Kiss, Z. *L' iconographie des princes Julio-Claudiens au temps d'Auguste et de Tibère*. Warsaw, 1975.

Kleiner, *Roman Sculpture*: Kleiner, D. E. E. *Roman Sculpture*. Yale, 1992.

Kurtz, D., and J. Boardman. *Greek Burial Customs*. London, 1975.

LÄ : Lexikon der Ägyptologie. 6 vols. Wiesbaden, 1975–1992.

Lamb, *Bronzes*: Lamb, W. *Greek and Roman Bronzes*. London, 1929.

Latomus: Latomus. Revue d'études latines.

LIMC: Lexicon Iconographicum Mythologiae Classicae. Zurich and Munich, 1974– .

Mattusch, C. *Greek Bronze Statuary: From the Beginnings through the Fifth Century BC*. Ithaca, New York, 1988.

MonAnt: Monumenti antichi.

Morris, D. *The Art of Ancient Cyprus*. London, 1985.

MüJb: Münchner Jahrbuch der bildenden Kunst.

Nicholls, *Corpus Speculorum*: Nicholls, R. V. *Corpus Speculorum Etruscorum*. Great Britain 2:

Cambridge. Cambridge, 1993.

Papathanassopoulos, G. A. Neolithic Culture in Greece. Athens: Museum of Cycladic Art. Athens, 1996.

Payne, Necrocorinthia: Payne, H. Necrocorinthia. A Study of Corinthian Art in the Archaic Period. Oxford, 1931.

Pollitt, J. J. The Art of Ancient Greece: Sources and Documents. Cambridge, 1990.

Pollitt, J. J. The Art of Rome circa 753 BC – 333 AD. Sources and Documents. Englewood Cliffs, N.J., 1966.

Ramage, N. H. and A. Ramage. The Cambridge Illustrated History of Roman Art. Cambridge, 1991.

Rasmussen, T., and N. Spivey. Eds. Looking at Greek Vases. Cambridge, 1991.

Ridgway, D., and F. R. Ridgway. Eds. Italy Before the Romans. The Iron Age, Orientalizing and Etruscan Periods. London, New York and San Francisco, 1979.

RM: Mitteilungen des Deutschen Archäologischen Instituts, Römische Abteilung.

RM-EH: Mitteilungen des Deutschen Archäologischen Instituts, Römische Abteilung. Ergänzugsheft.

Robertson, History: Robertson, M. A History of Greek Art. 2 vols. Cambridge, 1975.

Robertson, Vase-painting: Robertson, M. The Art of Vase-painting in Classical Athens. Cambridge, 1992.

Smith, Royal Portraits: Smith, R. R. R. Hellenistic Royal Portraits. Oxford, 1988.

Smith, R. R. R. Hellenistic Sculpture: A Handbook. London, 1991.

Snodgrass, A. M. The Dark Age of Greece. Edinburgh, 1971.

Spivey, N. Understanding Greek Sculpture. Ancient Meanings, Modern Readings. London, 1996.

Stern, Mold-blown Glass: Stern, E. M. Roman Mold-blown Glass: The First through Sixth Centuries. Toledo, 1995.

Stewart, Faces of Power: Stewart, A. Faces of Power: Alexander's Image and Hellenistic Politics. Berkeley, 1993.

Stewart, A. Greek Sculpture: An Exploration. New Haven, 1990.

Tatton-Brown, V. Ancient Cyprus. London, 1997.

Thimme and Getz-Preziosi, Art and Culture: Thimme, J., and P. Getz-Preziosi. Eds. Art and Culture of the Cyclades (Chicago and London, 1977).

Thomson de Grummond, Etruscan Mirrors: Thomson de Grummond, N. A Guide to Etruscan Mirrors. Tallahassee, 1982.

Trendall, A. D., and A. Cambitoglou, Red-figured Vases of Apulia, 2 vols. (Oxford, 1978, 1982).

Uhlenbrock, Coroplasts's Art: Uhlenbrock, J. P. The Coroplasts's Art. Greek Terracottas of the Hellenistic World. New Rochelle, New York, 1990.

Vandenabeele and Laffineur, Cypriote Terracottas: Vandenabeele, F., and R. Laffineur, Cypriote Terracottas. Brussels and Liège, 1991.

Vollkomer, Herakles: Vollkommer, R. Herakles in the Art of Classical Greece = Oxford University Committee for Archaeology Monograph 25. Oxford, 1988.

Walberg, G., Tradition and Innovation. Essays in Minoan Art. Mainz, 1986.

Walker, S. Greek and Roman Portraits. London, 1995.